*Let the Spirit of Alaska
nourish your soul!*

Jimmy Thill

The Spirit of Alaska
Volume 3

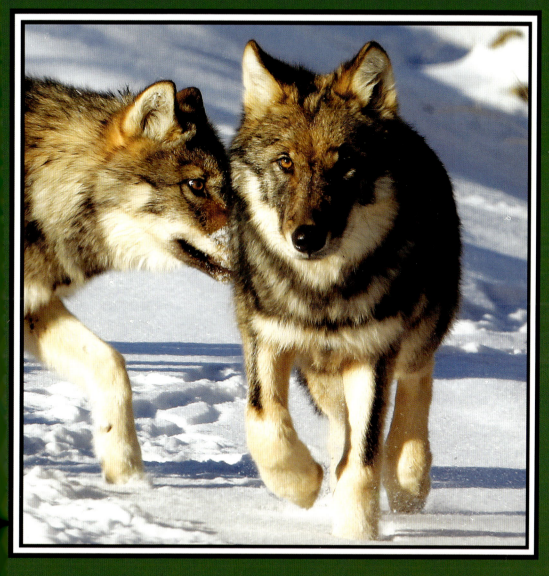

by Jimmy Tohill

The Spirit of Alaska

Copyright © 2015 by Jimmy Tohill. All rights reserved. This book may not be reproduced in whole or in part without the written consent of the publisher.

Library of Congress Control Number: 2011927651

ISBN: 978-1-57833-629-6

First Printing: December 2015

Photography and poetry - Jimmy Tohill
Design and layout - Jimmy Tohill
Final file preparation, review and layout - Vered Mares / Todd Communications

Printed by Everbest Printing Co., Ltd., in Guangzhou, China
through Alaska Print Brokers, Anchorage, Alaska

Published in Healy, Alaska by Jimmy Tohill / Old Sourdough Studio - Denali

For additional copies contact:
Jimmy and Vicki Tohill / Old Sourdough Studio
P.O. Box 455 Healy, Ak 99743
907-683-1011
oss@mtaonline.net
www.oldsourdoughstudio.com
www.thespiritofalaska.com

or stop by Old Sourdough Studio
at the McKinley Chalet Resort - Mile 238.5 Parks Hwy., Denali, AK.

Cover photo: A bull moose (Alces alces) with velveted antlers splashes through the calm water of Wonder Lake in Denali National Park just as the sun is setting around 10:15 pm in late July.

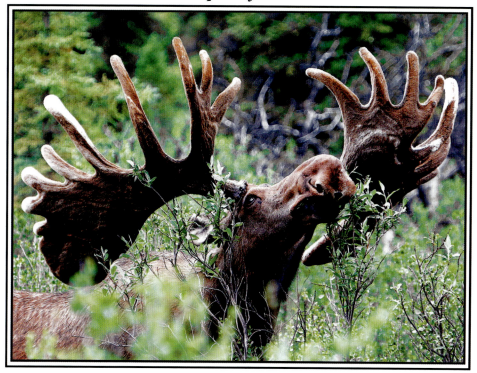

Table of Poems

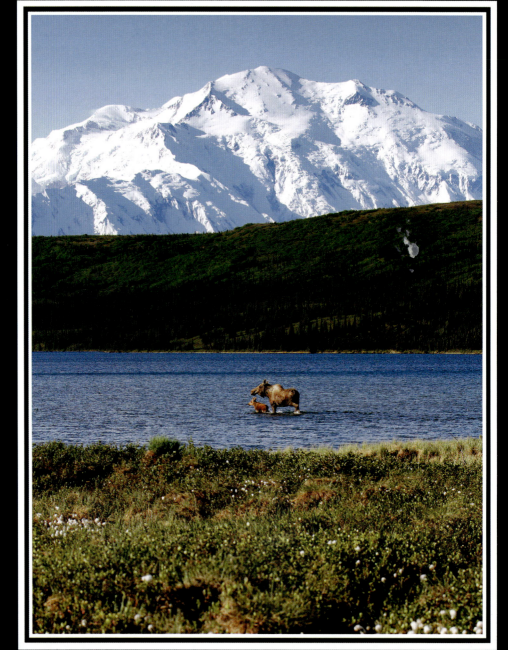

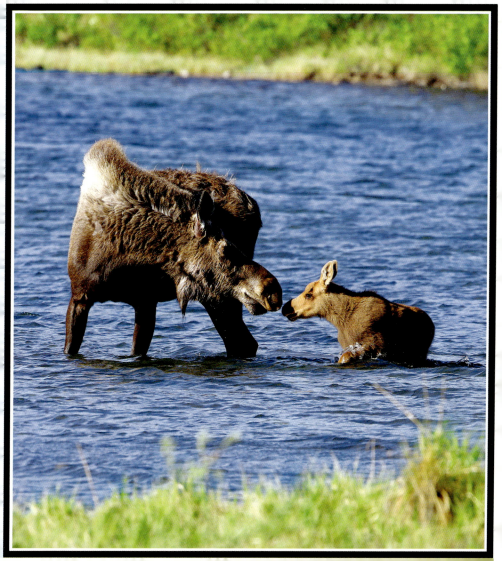

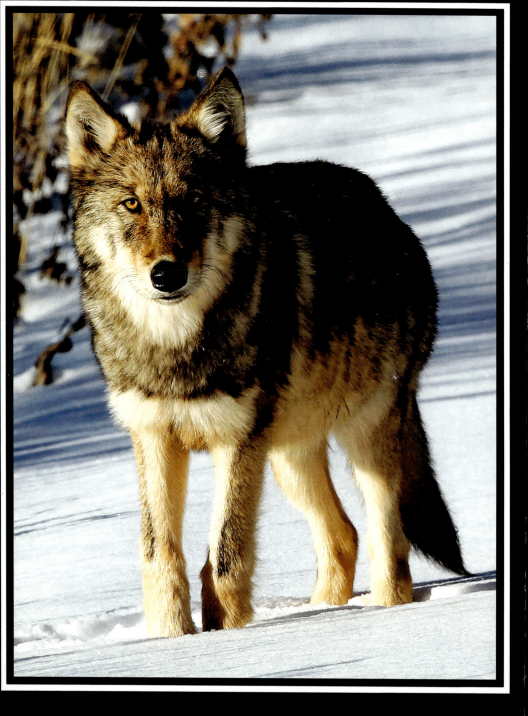

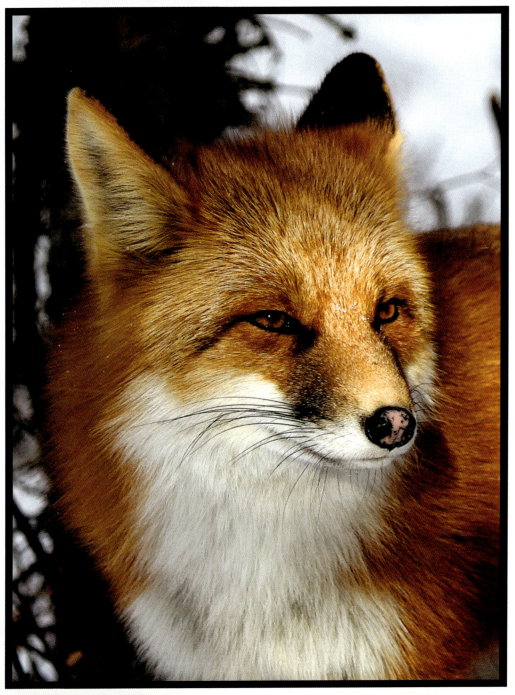

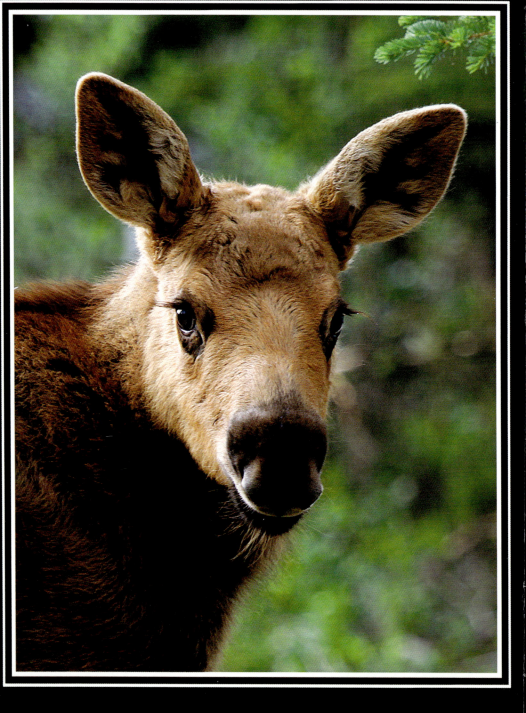

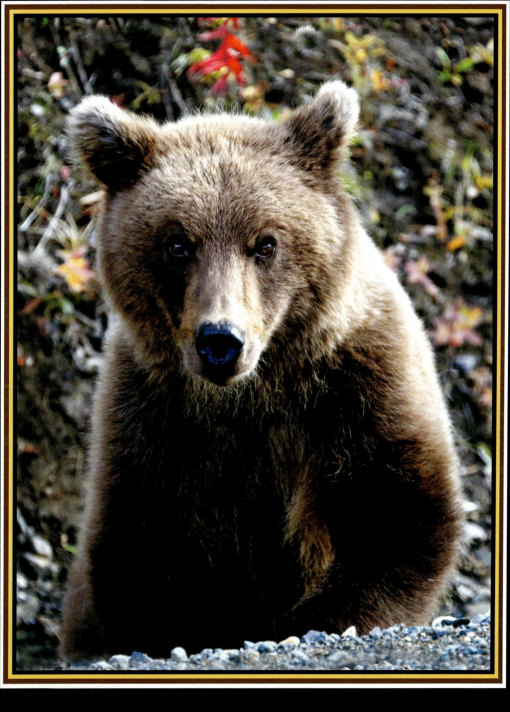

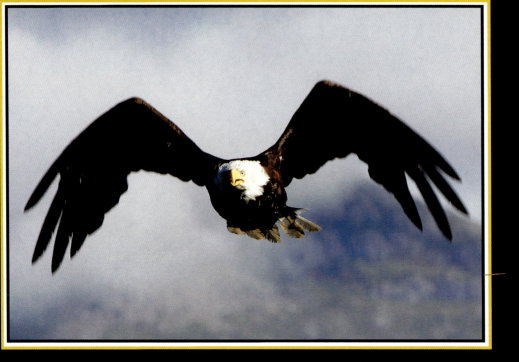

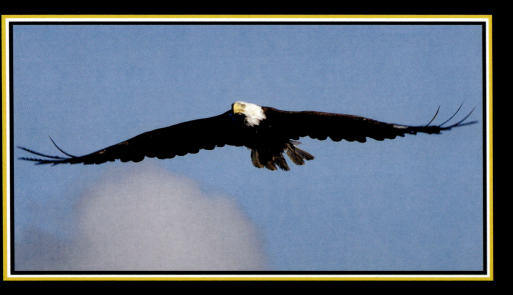

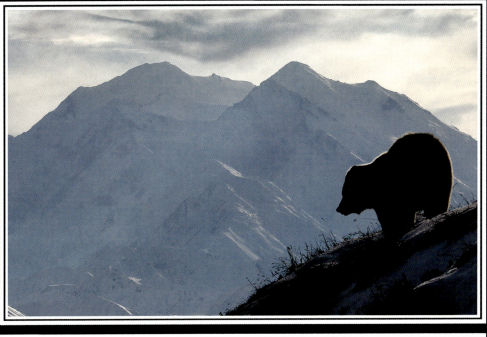

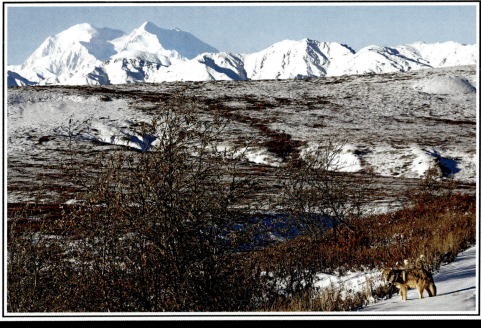

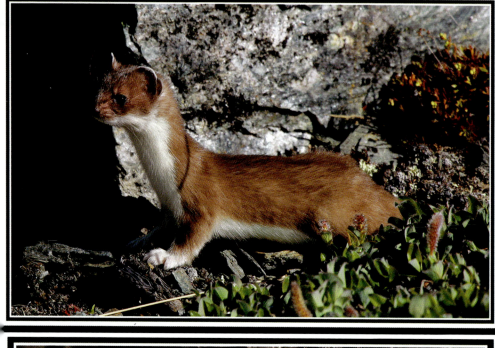
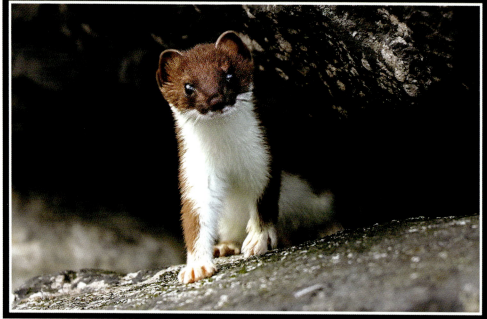

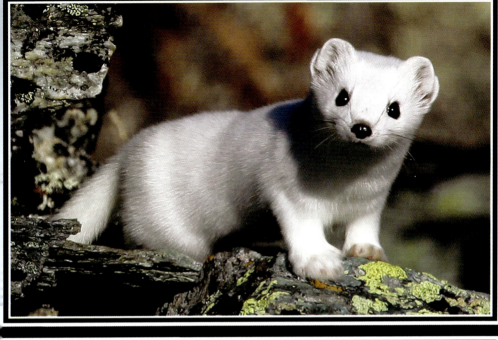
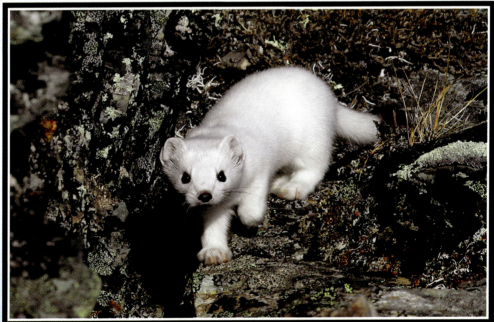

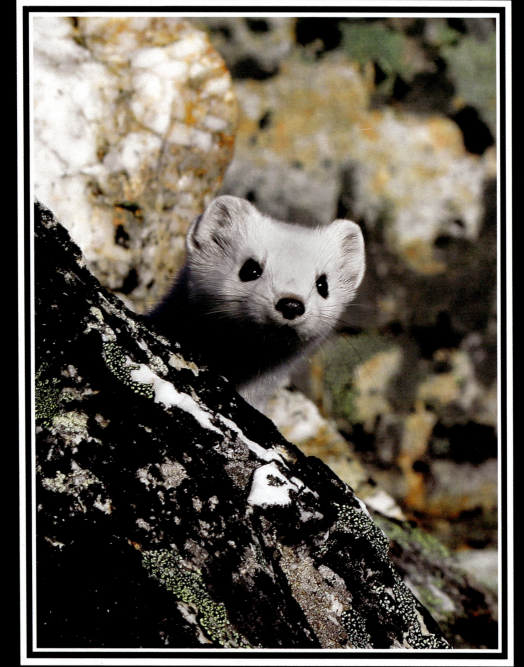

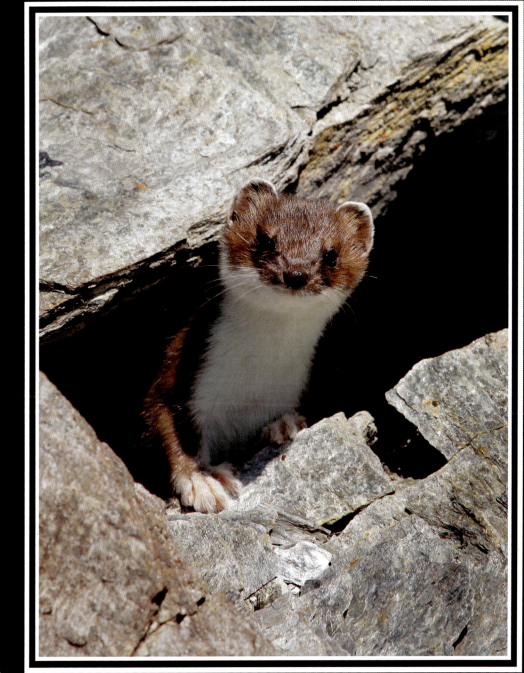

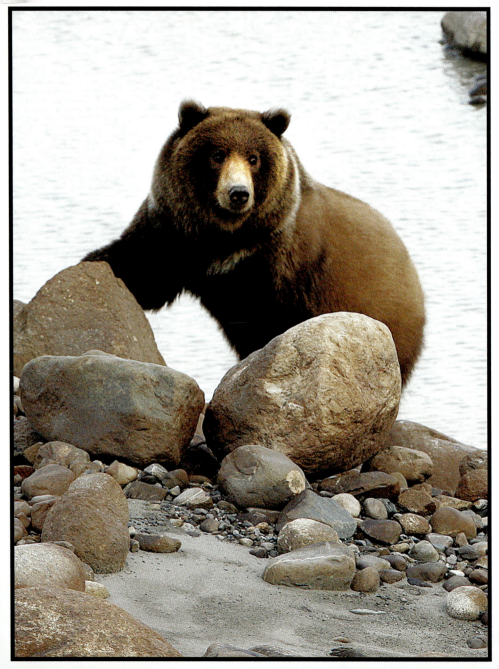

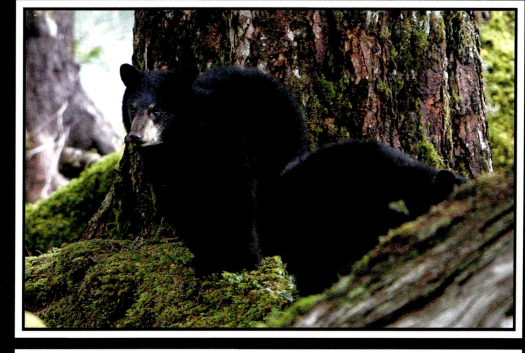

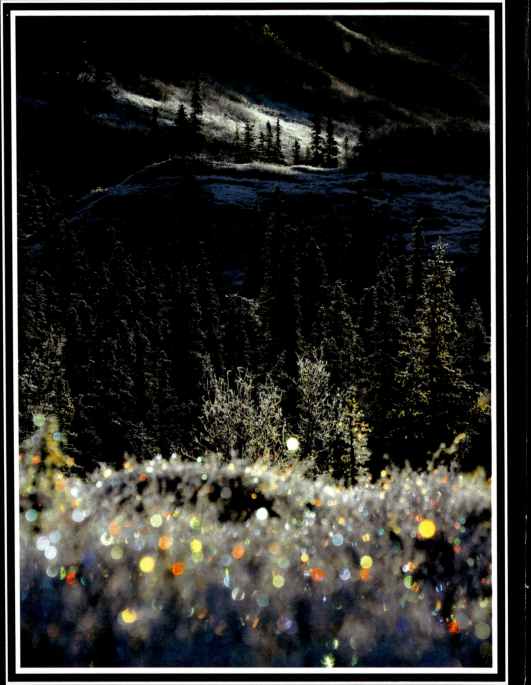

The Spirit of Alaska (part 3)

The Spirit of this land has a far reaching hand
 that can be rather soothing for me and for you.
It is absolutely immense and can be seriously intense
 due to the extremes that tend to accrue.

The temperatures can swing in the winter and spring
 sixty to seventy degrees in a single day.
It can be calm at first light and howlin' eighty by night,
 the extremes can literally blow you away.

This demands a respect that can make you reflect
 on the powers that happen to be.
It will make you aware like the wolf and the bear,
 and awareness is certainly a key.

The Spirit of Alaska has powers like the glacier that scours
 wide valleys over thousands of years.
The Spirit of Alaska is as strong as the summer day is long
 and that strength can help take away all fears.

A brown bear in a river can conjure up a shiver
 as it frantically fishes for a meal.
A black bear on the shoreline seems to have more time
 while looking for a bed of mussels through feel.

A white snowy owl is a beautiful fowl
 that thrives in the Arctic tundra land.
The bald eagle screeches as it searches the beaches
 looking for a snack on the sand.

A pod of orcas in the bay suddenly appear and begin to play,
 rubbing their bellies on the gravel below.
King crabs make a dish of a constellation of starfish,
 enabling these huge crustaceans to grow.

A raft of sea otters afloat near a solitary sail boat
 eating clams that they dug from the sea floor.
With their pups on their chest making a soft furry nest,
 the otters rarely but occasionally go to shore.

An ermine will turn white with the approach of winter's night
 and lose its summer tuxedo-like suit.
A snowshoe hare does the same at the end of fall's flame
 and the bunnies, all white, sure look cute.

The Spirit of Alaska (part 3)

A northern hawk owl in a tree is fairly easy to see
 with its striped chest and its long tapered tail.
A flock of ptarmigan take flight and if close by can cause fright
 from the loud sound made when all their wings take sail.

All the creatures that are here in this fantastic frontier
 help make up the essence of the Spirit of Alaska.
Then there is all the lush greenery, the magnificent vast scenery
 and the great mountain named Denali by the Athabasca.

The high peak called Denali will make you say golly
 if you ever get the chance to be near it.
With the glacial rivers of ice and the other mountains so nice,
 this a monumental part of Alaska's true Spirit.

There is a vastness of the land that is impressively grand
 that stretches over half a million square miles.
From the northern Arctic plain to the never ending Aleutian chain
 and all of the southeastern sea isles.

From the tiny blueberry flower to giant hemlocks that tower,
 the Spirit of Alaska is made up of all different sizes.
From ferns six feet tall to the colorful tundra in the fall,
 the Spirit of Alaska is full of surprises.

It is quite the surprise to view a winter sunrise
 that can be so vivid it's hard to explain.
With all the reds and the blues displayed in hundreds of hues,
 it might be cold but it's hard to complain.

There is a diversity so deep it can make a grown man weep
 with sincere wonder and splendor inside.
It's a deepness so real it can fill you with zeal;
 you'll find an awareness that opens the heart wide.

The Spirit of Alaska is there just floating in the air,
 steady and ready to take hold
with a true since of peace that will simply not cease
 and will certainly never get old.

The people that call this home and all of the creatures that roam,
 from one end of Alaska to the other,
feel its pure Spirit because they are so near it
 and it nourishes their soul like their mother.

The Spirit of Alaska (part 3)

A truly nourished soul is treasured by the whole,
 and contentment just slips right in.
Simply experience the wild, from the extremes to the mild,
 as we revolve around the sun once again.

The Spirit will settle in your heart and you will feel that you are part
 of the magnificence of the marvels at hand.
And we are all more well rounded when we learn to be grounded
 by the Spirit that is the pulse of the land.

Let the Spirit of Alaska nourish your soul!

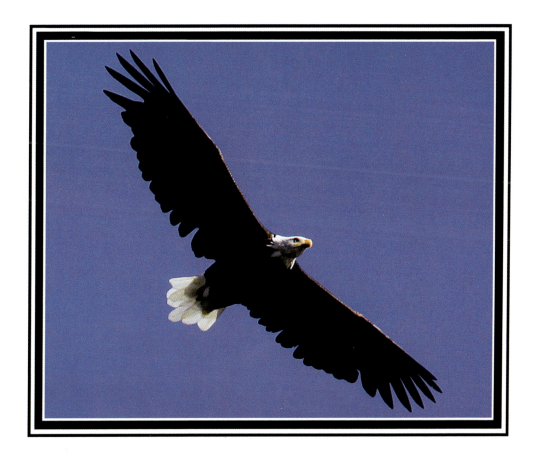

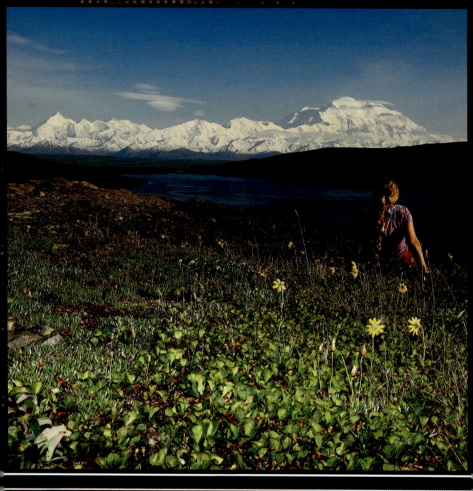
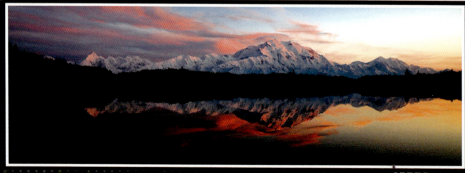

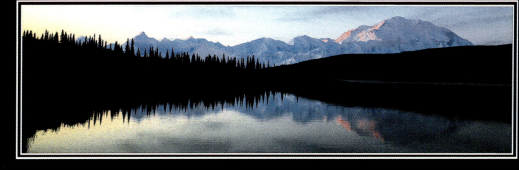
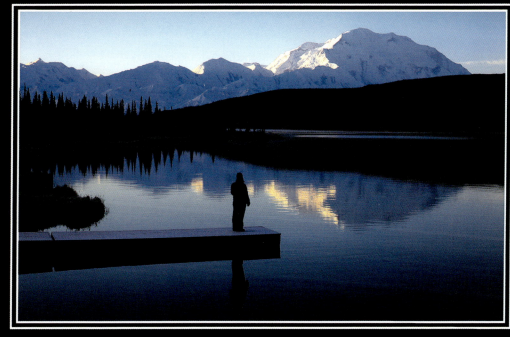
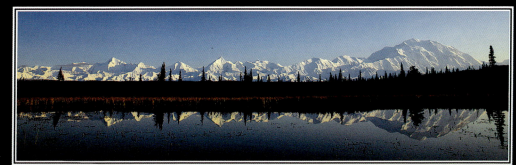

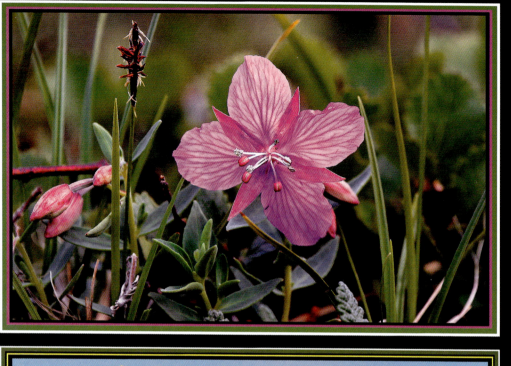

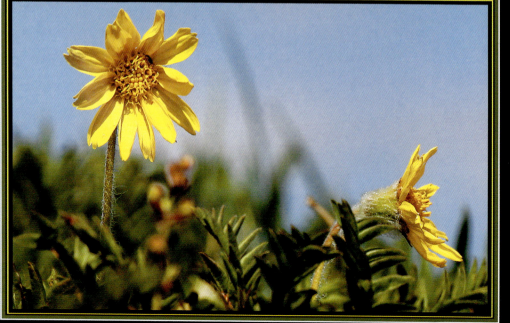

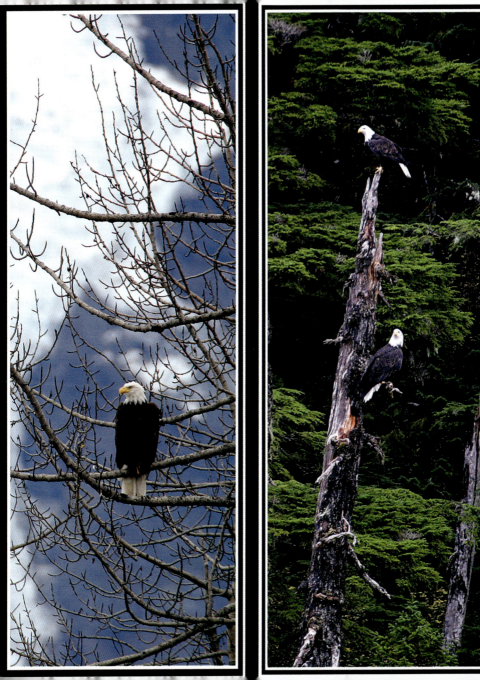

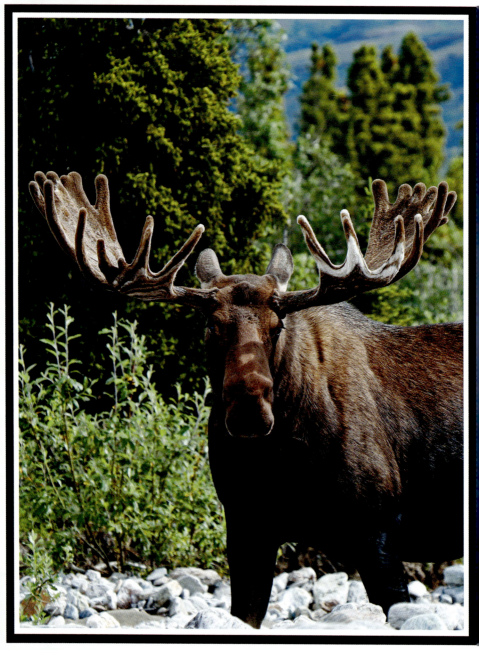

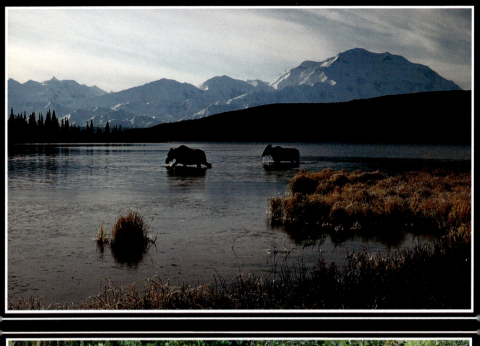

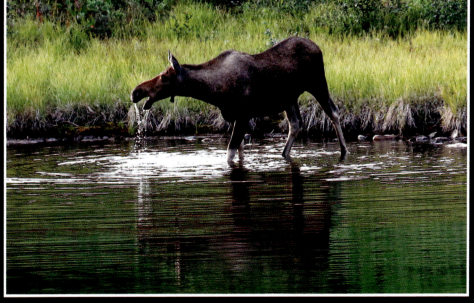

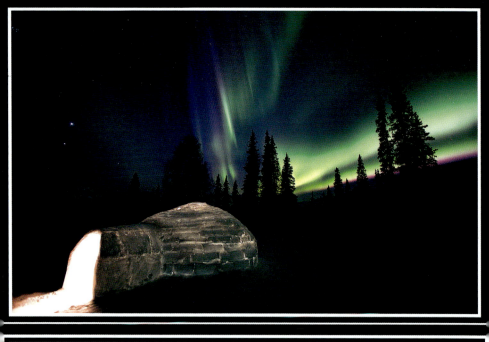
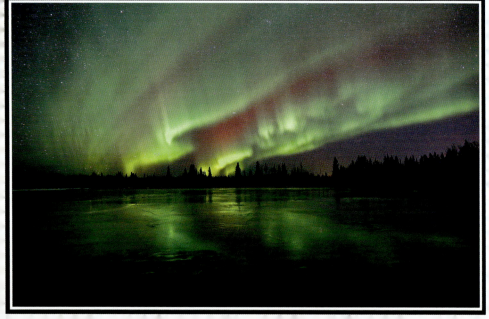

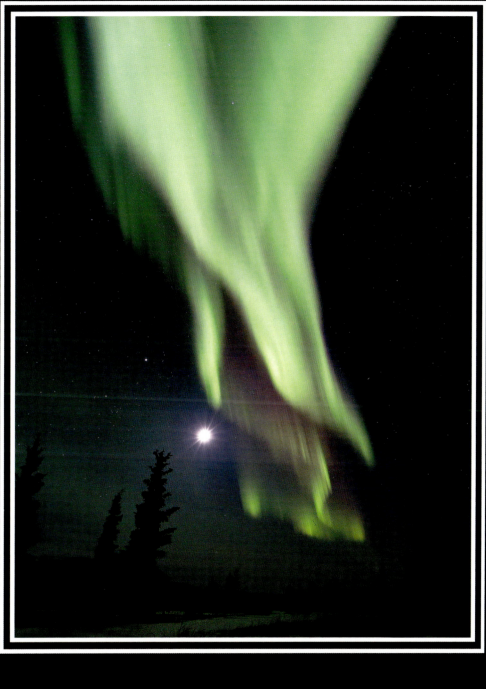

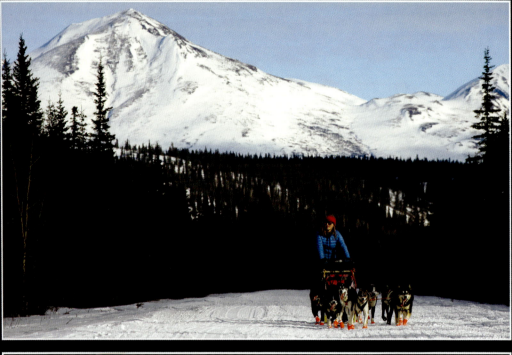

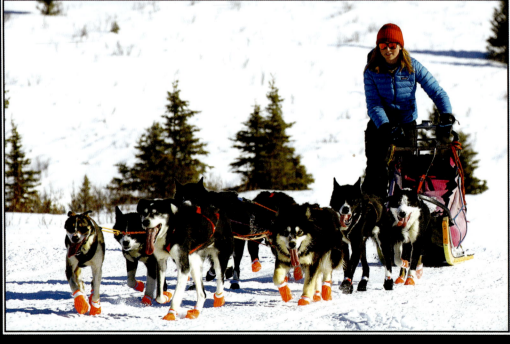

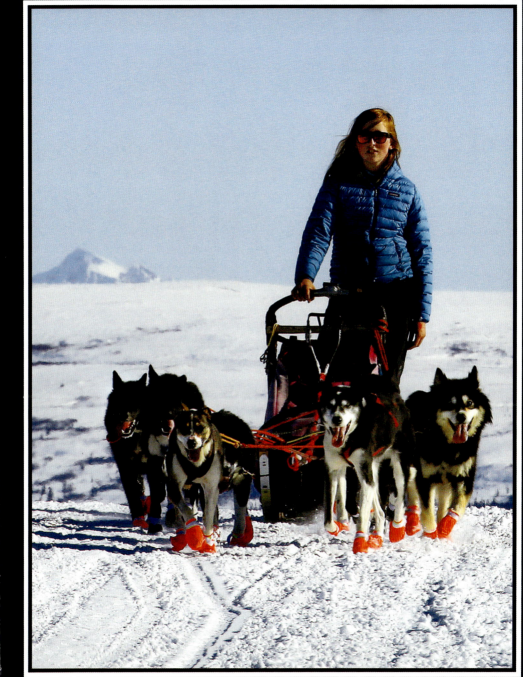

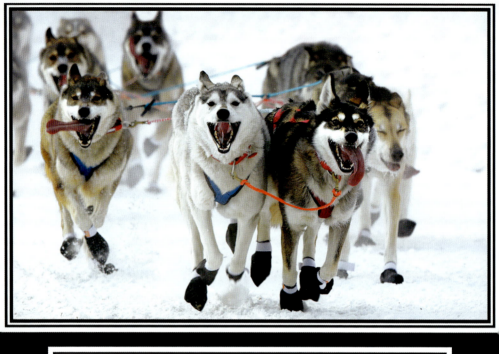

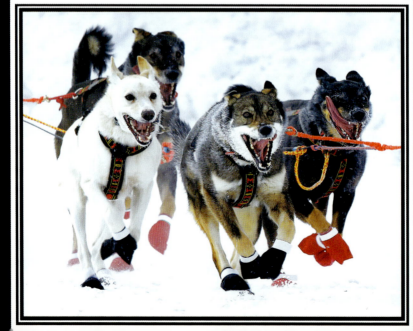

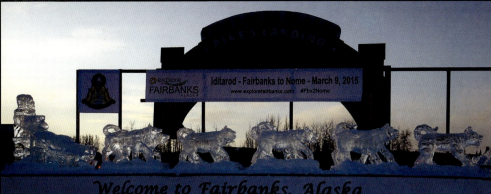

Welcome to Fairbanks, Alaska
"THE Ice Sculpting Capital of the World"

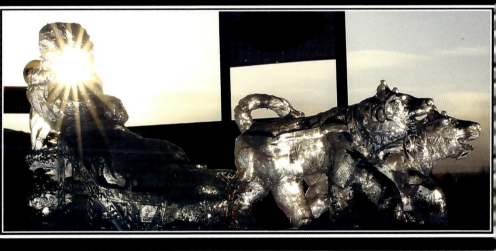

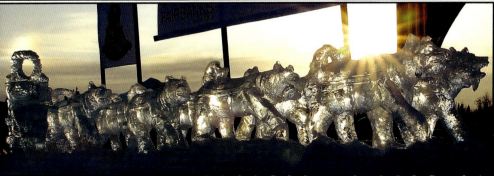

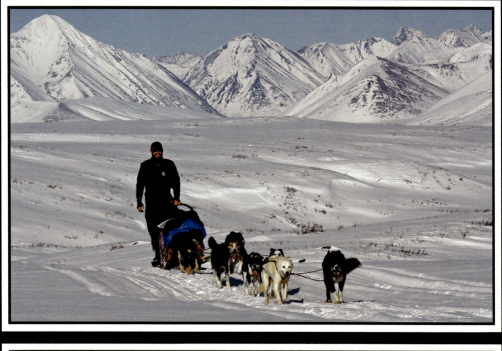

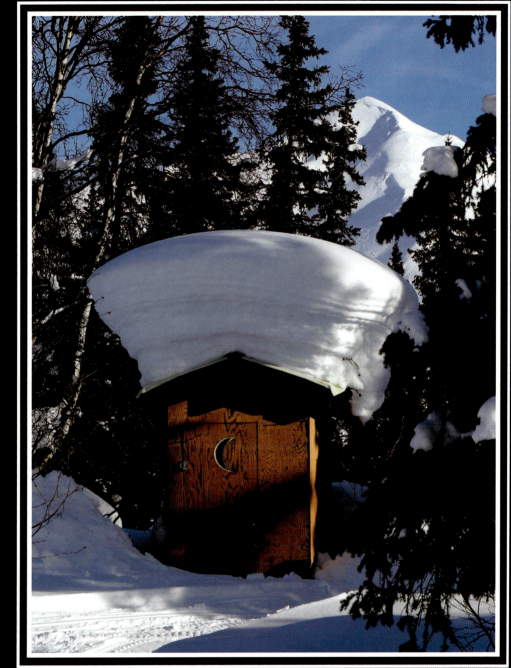

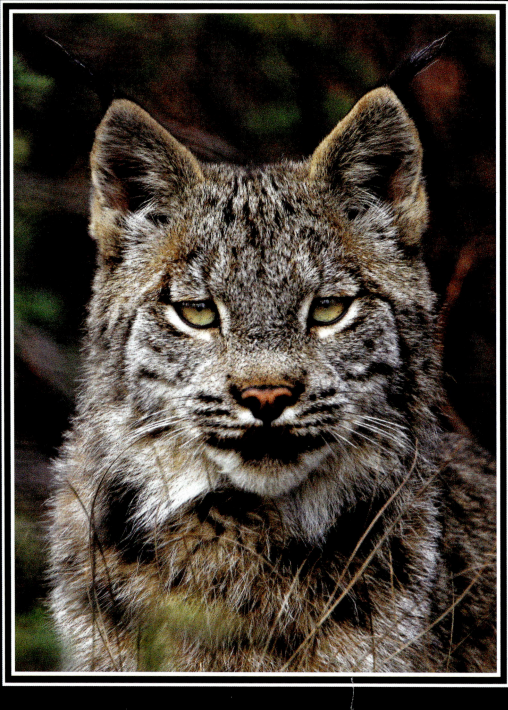

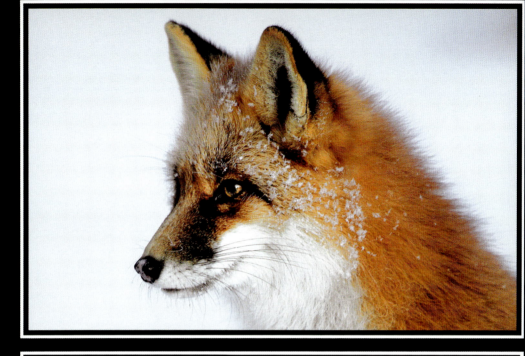

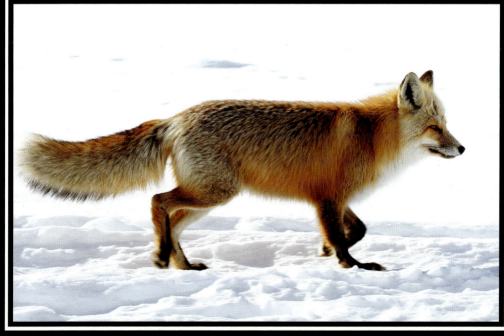

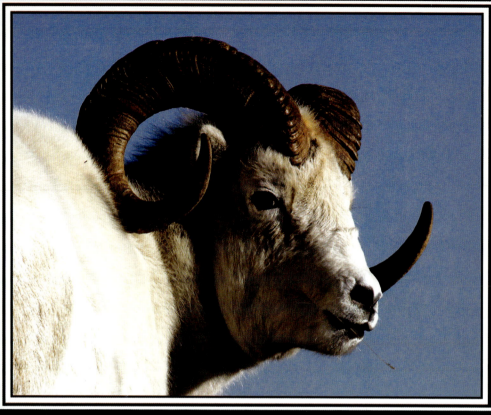

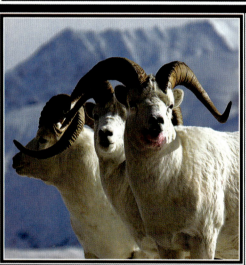

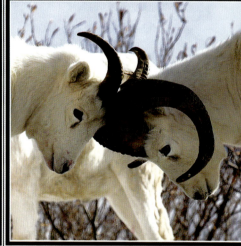

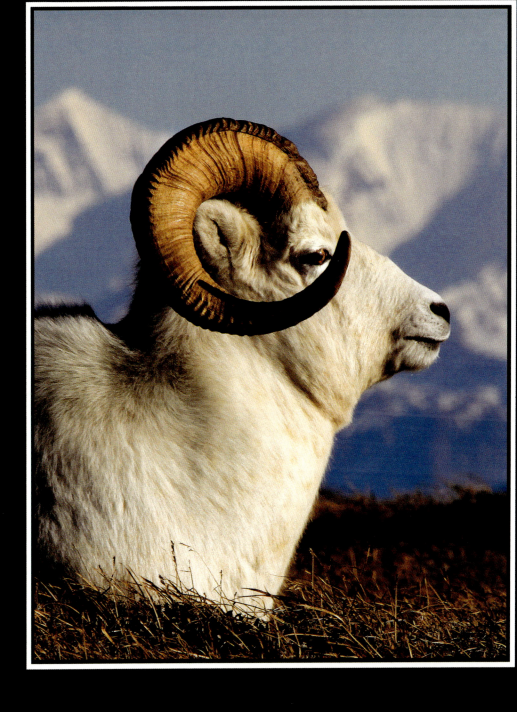

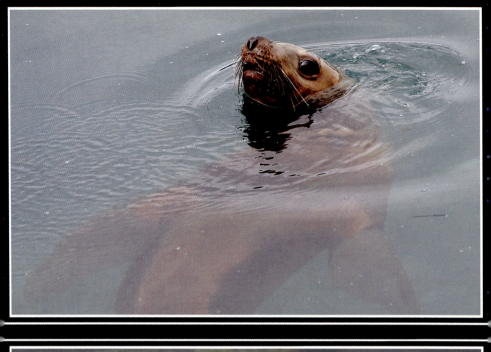
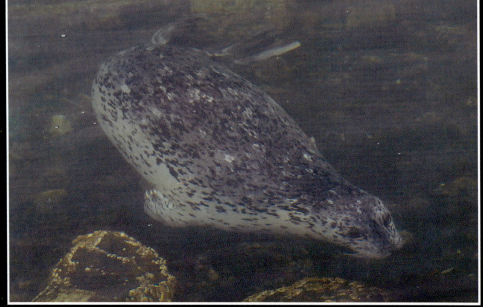

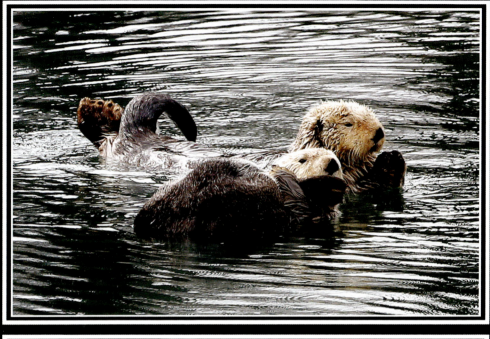

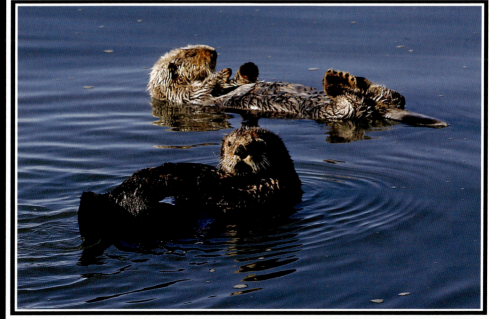

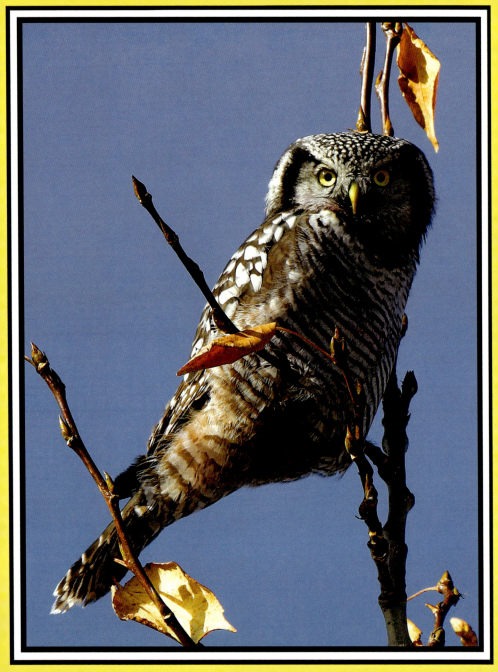

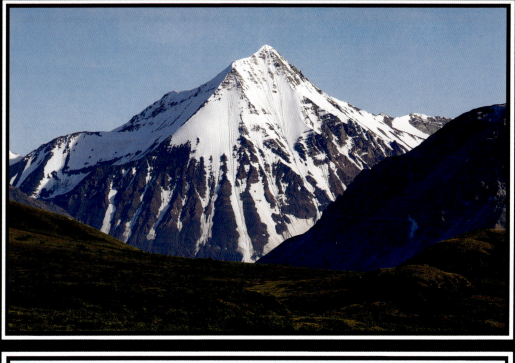

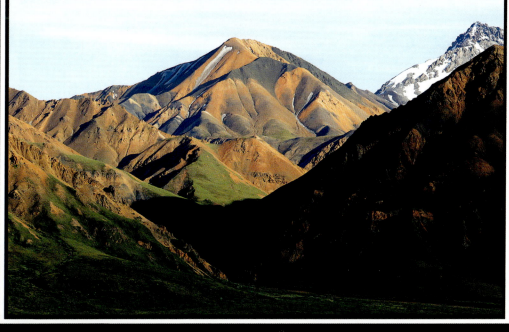

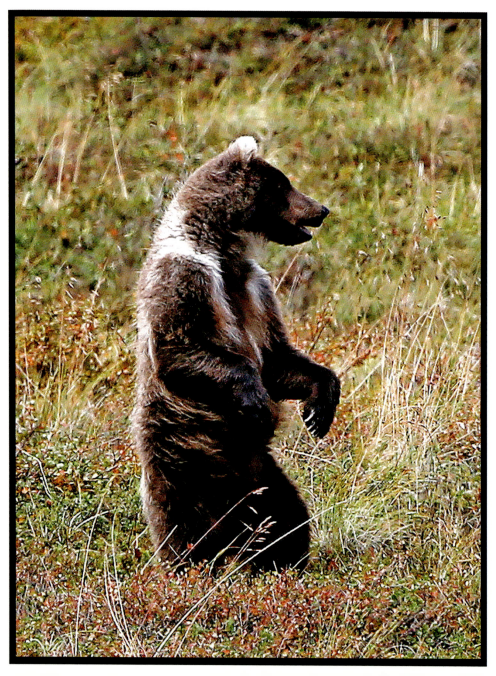

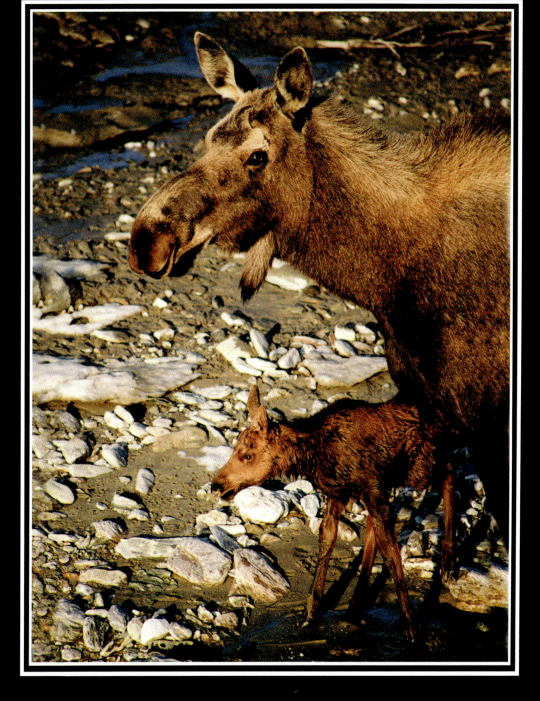

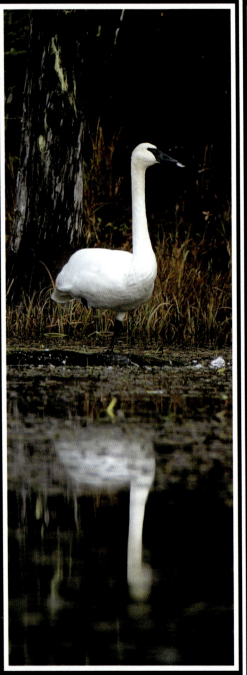
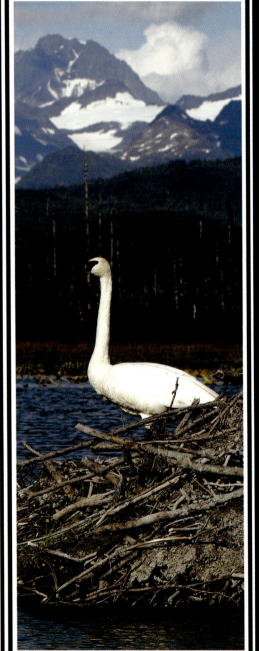

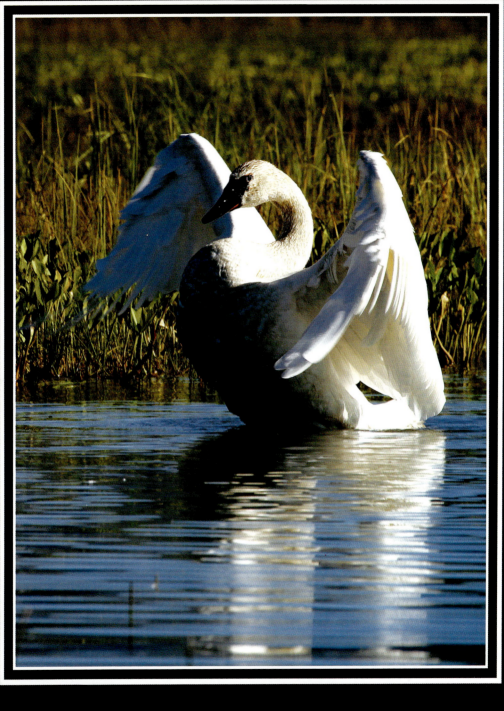

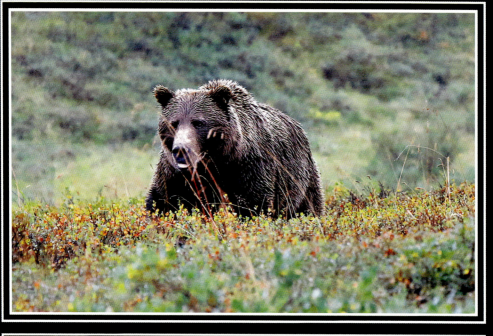

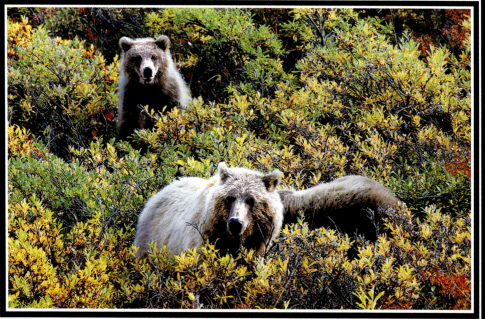

Tundra

There is a place in the north where the caribou graze
on dwarf birch and willows during the long summer days.

They'll eat sedges, mushrooms, grasses and flowers;
on the tundra in the summer they will eat these for hours.

In the winter these foods dwindle and they all cease to grow.
The caribou must dig for lichen and moss buried under the snow.

The tundra that sustains the caribou throughout all of the year,
to the casual observer is barren, or so it seems to appear.

But a closer look with awareness and you will certainly find
that there is an abundance of life and it is one of a kind.

All of the shrubs are dwarfed and tall trees are not found
but there is a diversity of plant life growing close to the ground.

Bog blueberries, lingonberries and crowberries too,
a large variety of willows, some old and some new.

Bear flowers, Eskimo potato and dwarf fireweed;
to bears on the tundra these are a delicious fine feed.

Moss campion and elegant paintbrush and northern oxytropes;
there are hundreds of different flowers growing on tundra meadows and slopes.

There are lupine, bluebells and forget-me-nots all blue.
There is the vole and the lemming and six species of shrew.

The pika, the marmot and the snowshoe hare,
the ermine, the wolverine and the grizzly bear.

A quiet lynx on the tundra is a magnificent sight.
A pack of wolves on a hunt in the middle of the night.

A fox trots the open tundra in search of some prey
as a big bull moose stands up and saunters away.

Dall sheep, they live up in the tundra's high peaks
wary of the golden eagle as it soars by and shrieks.

A river otter hangs out in a high tundra lake.
The tundra is definitely not barren, it is alive and awake.

The great horned, great gray and the northern hawk owl,
there are geese and swans and all sorts of water fowl.

The bufflehead, the northern shoveler and the common goldeneye duck,
there are spruce grouse and willow ptarmigan that waddle about and cluck.

Tundra

Loons and grebes hang out on kettle ponds.
A raven crows loudly and its life partner responds.

A gyrfalcon has its eye on a flock of sandhill cranes
as they circle and land in the midst of downpouring rains.

Golden plovers feast on insects and they will eat berries as well.
A mew gull dive bombs a fox to prevent a broken eggshell.

And the caribou keep grazing, as they have done in the past,
across the tundra so plentiful, so delicate and vast.

The tundra is alive and more diverse than it seems
as the sun lights up its fall colors with radiant beams.

It's treeless, it's expansive, it is a fascinating place.
Take a walk on the tundra, breath deep and embrace!

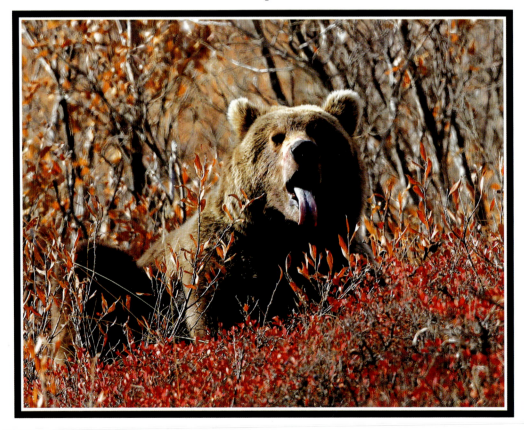

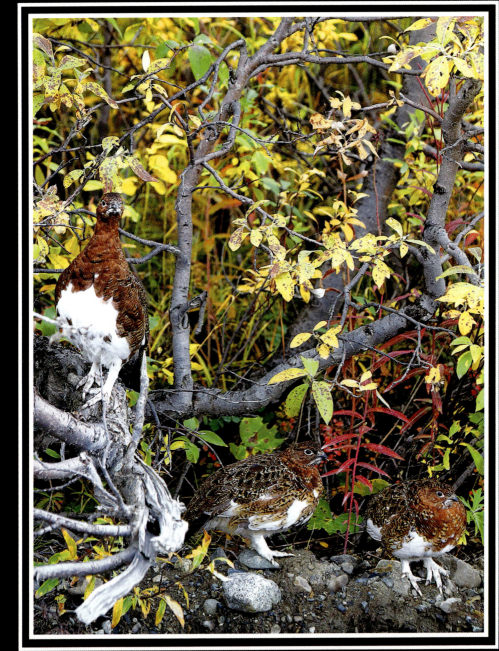

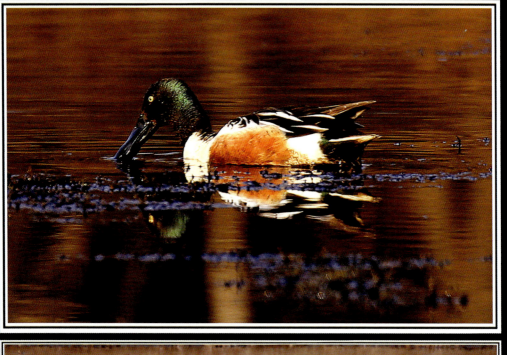
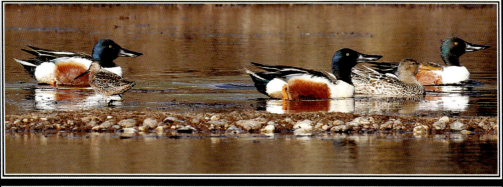
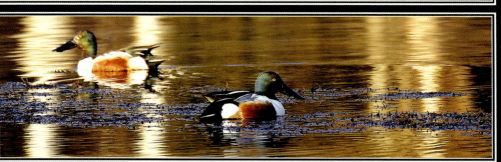

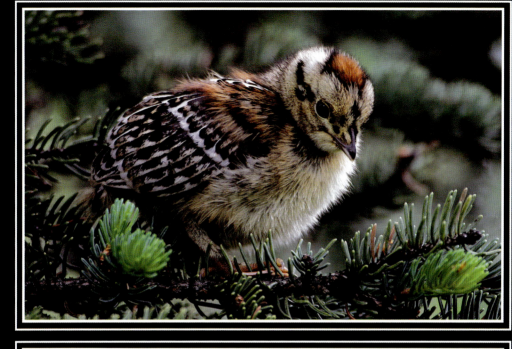

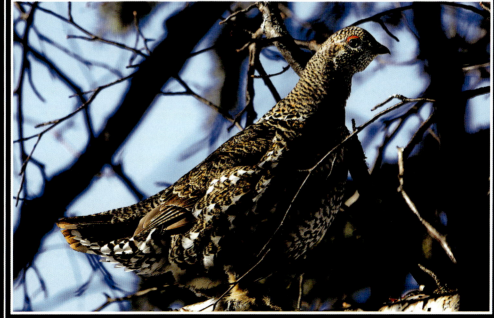

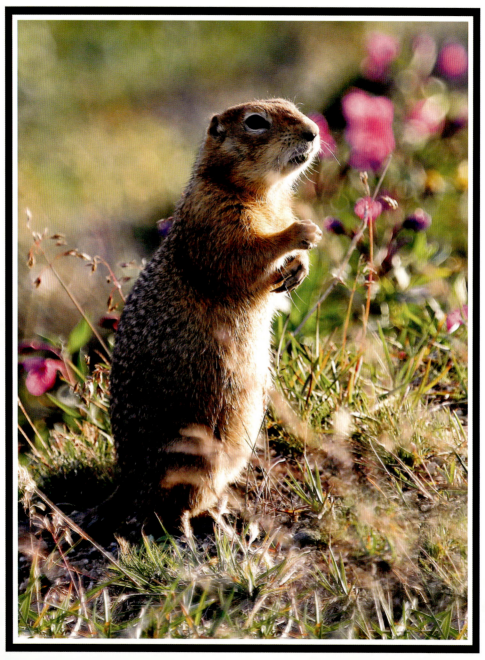

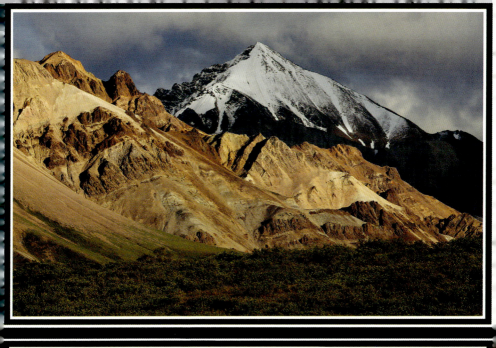

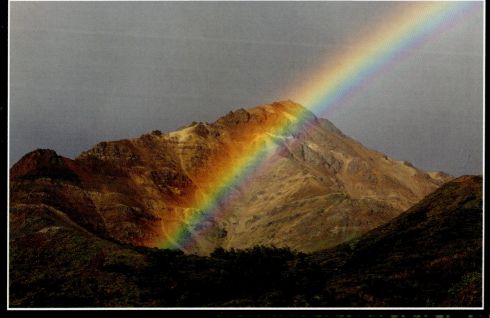

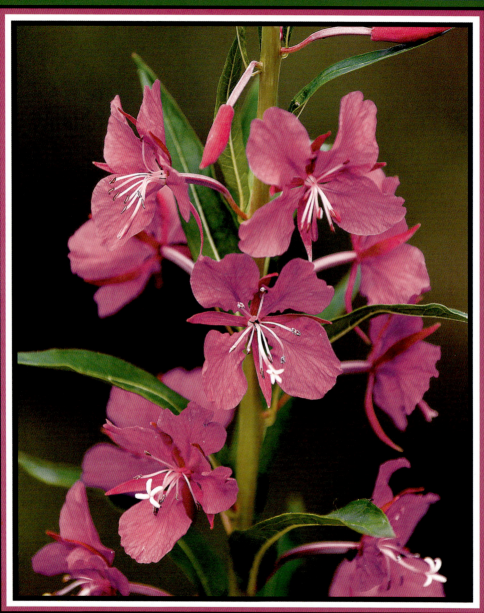

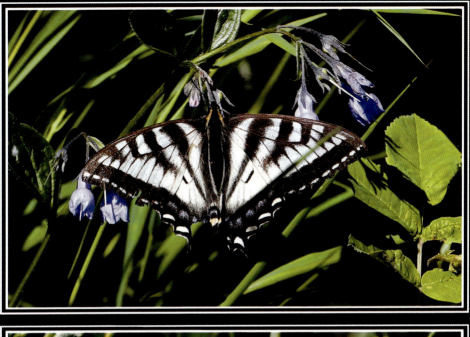

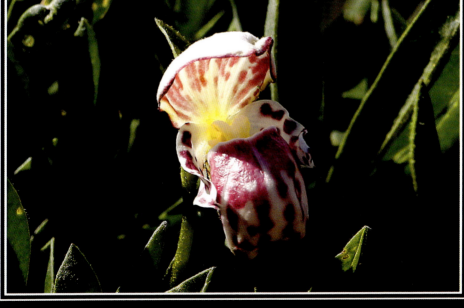

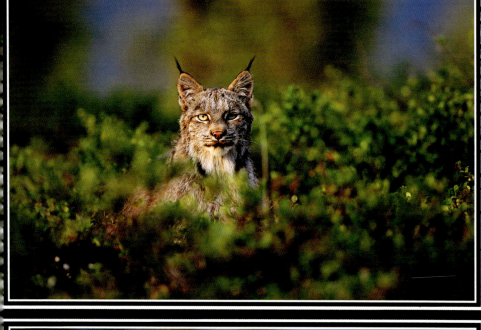
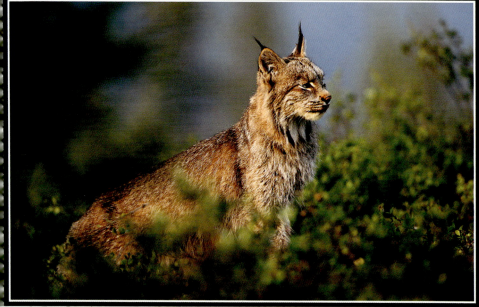

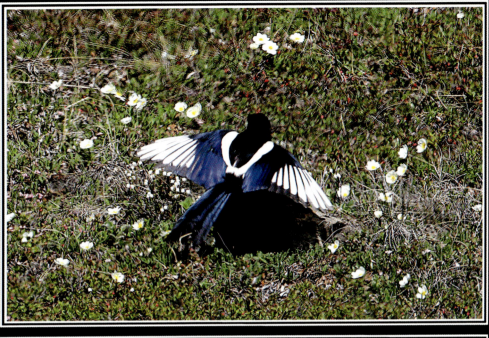

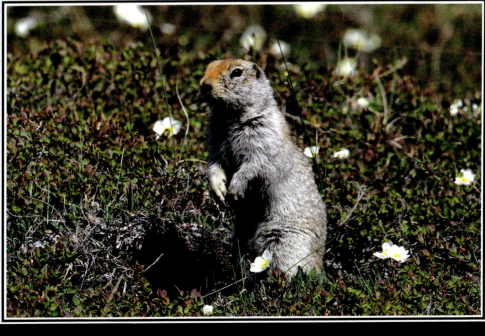

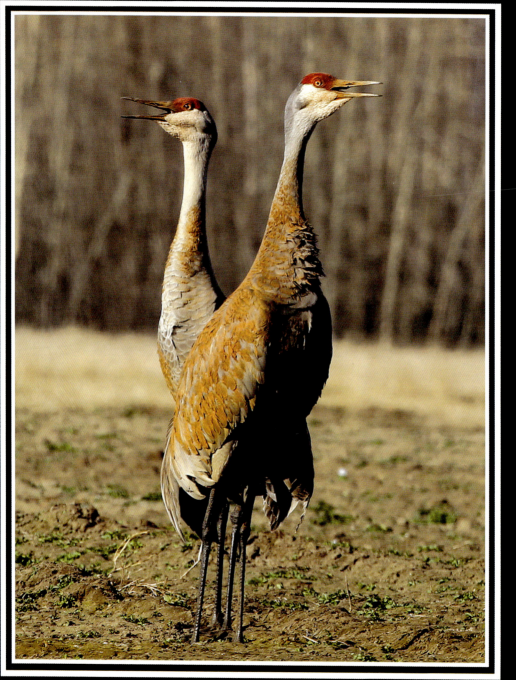

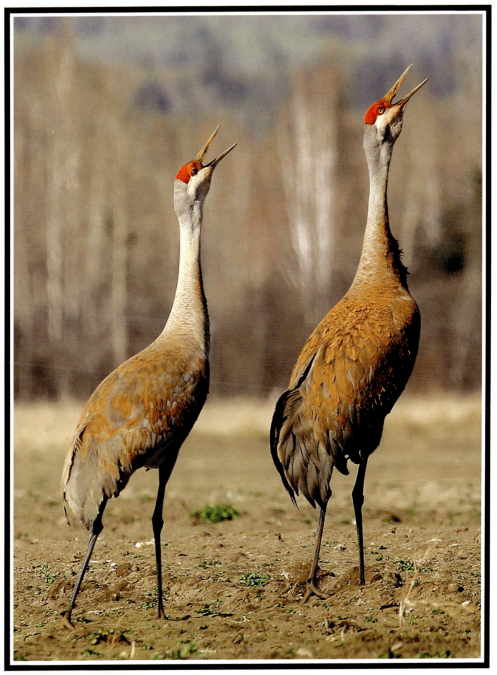

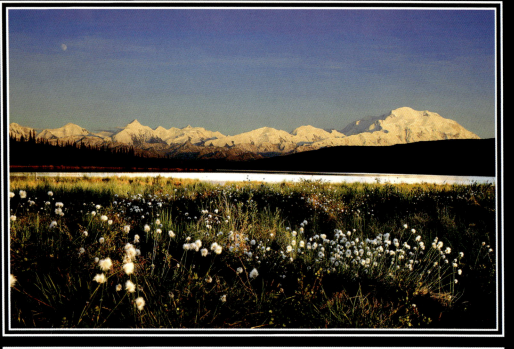

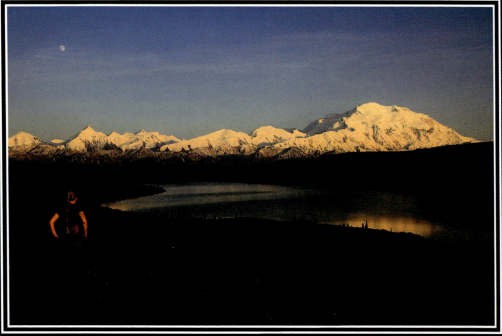

Alaska's Summer Sun

The sunset in the summer slowly happens right around midnight,
turning their white wings to gold as the mew gulls feed in flight.

Casting its low angle light out across the magnificent land,
the setting sun makes long shadows of a gnarled old black spruce stand.

The sun, it sets in the north and seems strange to someone that's new.
As it sets it throws to the south an extraordinarily vivid hue.

The hue can range from magenta to gold and turn clouds a purplish red.
At midnight in the summertime the splendid colors will spin your head.

Spin your head around like an owl as you take in this spectacular treat.
A summer sunset in Alaska provides a splendor that is hard to beat.

The sunset turns into a sunrise right before your very eyes.
The beautiful brilliant colors are emblazoned upon the skies.

Every day the show is unique and different and never quite the same.
There are pinks and reds and purples and more oranges than one can name.

You might hear your neighbor out mowing his yard because it just stays so light.
At twelve AM in the summertime - anything goes when there is no night.

People tend to take advantage of the never ending summer days.
You can go fishing at three in the morning as the sun continues to blaze.

You can climb a mountain at midnight, sit on top and take in the vibrant view.
With the never ending light of the summer there are never ending things to do.

The wild creatures of Alaska take advantage of Alaska's long summer days,
from the bears that tend to feed all night long to the caribou's perpetual graze.

The Dall sheep can navigate the steep mountain ridges right on through the night.
The birds can constantly feed on insects as there is no darkness to hinder their flight.

Shrubs and grasses and flowers grow quite fast with the long summer sun.
Moose, they really appreciate this as they gorge on leaves by the ton.

It restores all life in a hurry, it rejuvenates it so fast.
Summertime in Alaska is short, it is known that it won't last.

But while it's here there is a magical feel that penetrates the soul.
The summer sun in Alaska has the power to make things whole.

The wholeness is there into the fall, through the winter and persists into spring.
The power of the summer sun in Alaska is an incredibly remarkable thing.

Enjoy the summer!

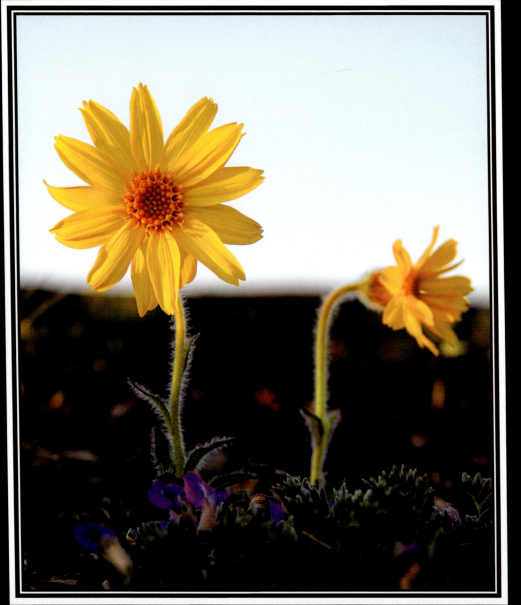

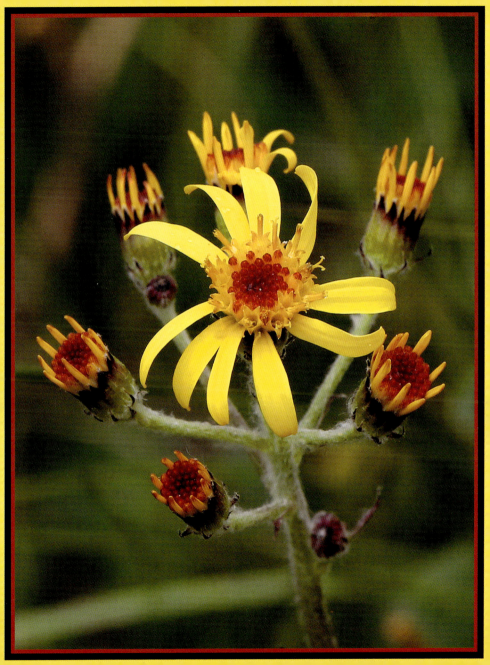

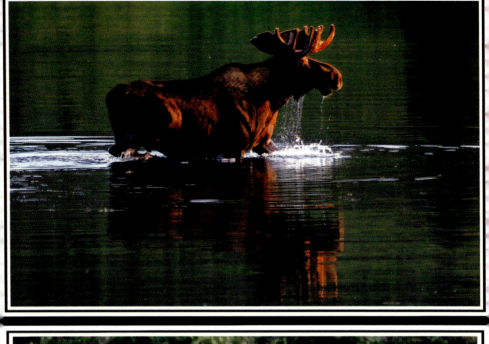
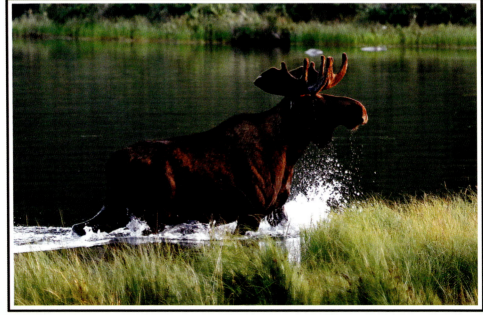

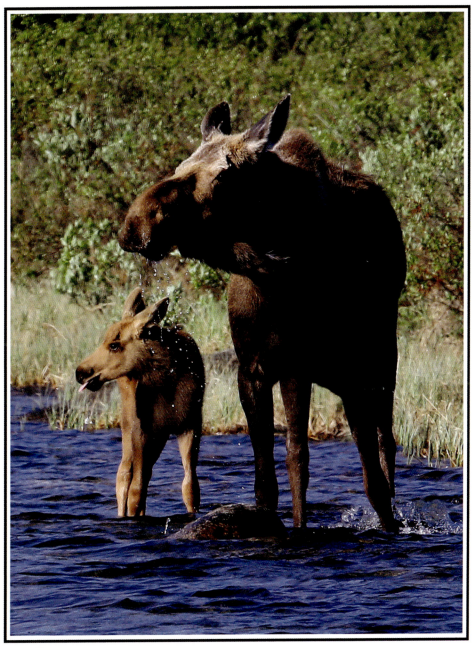

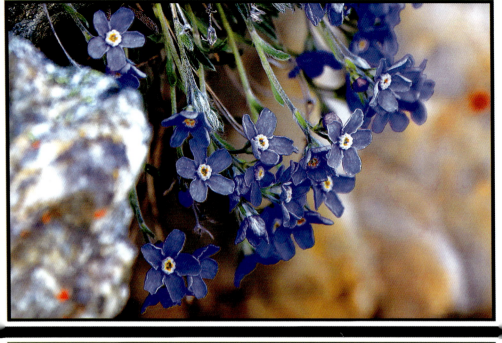

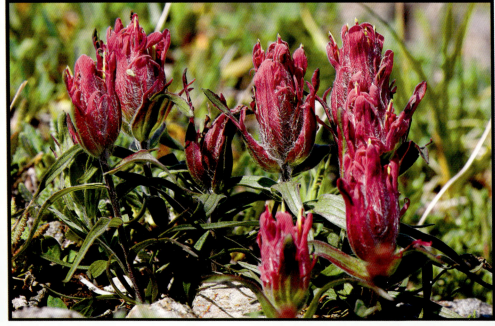

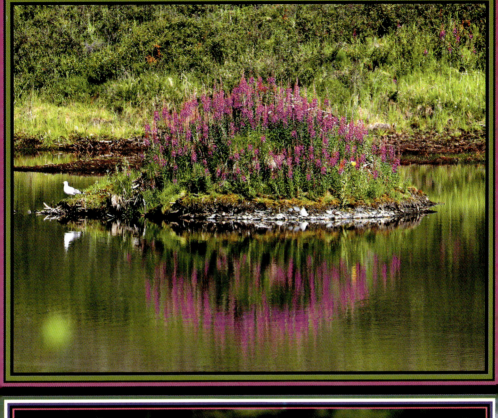
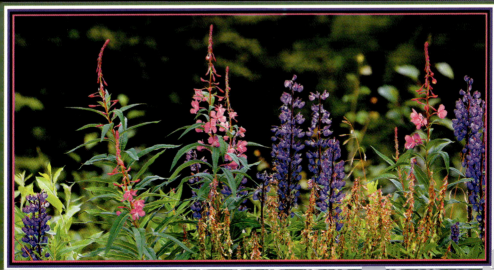

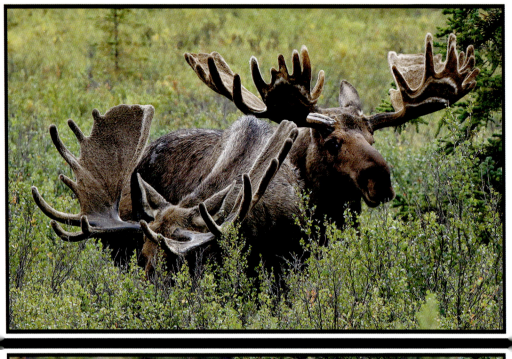

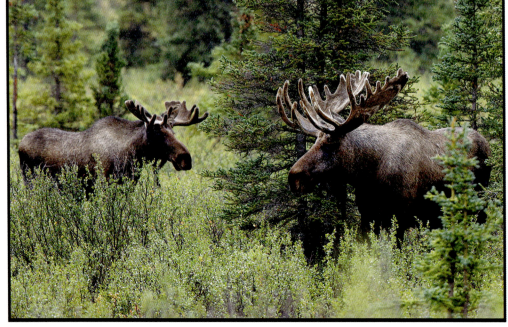

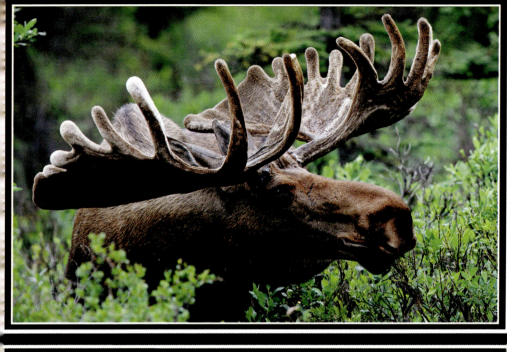
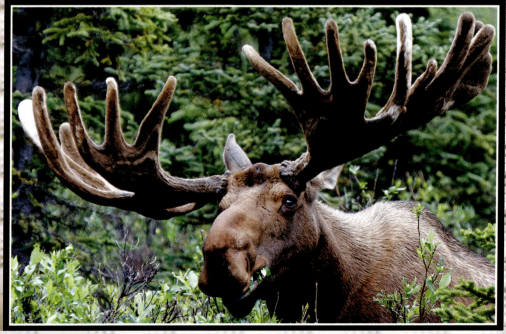

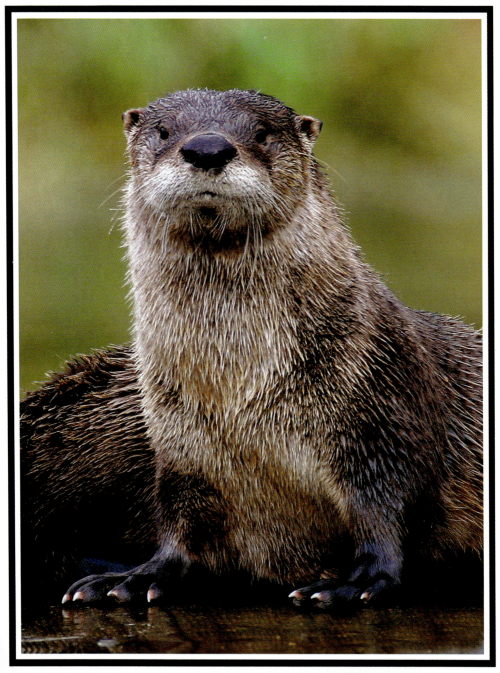

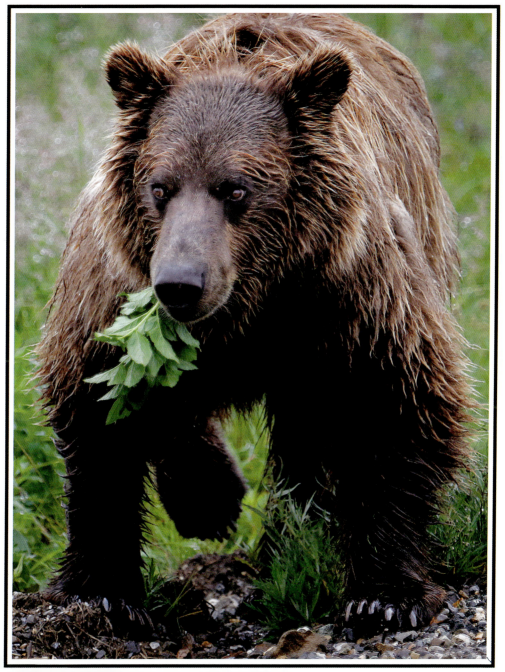

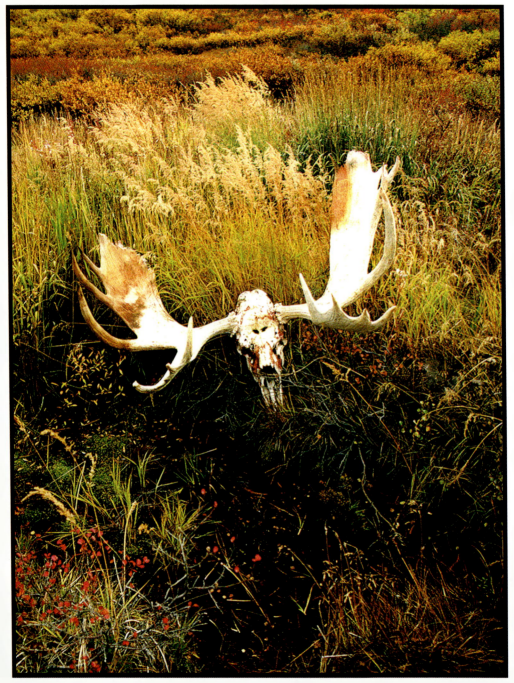

The moss grows thick from abundant rain
and the ferns stand tall.
The rivers, they roar
as they carry away the old
and rearrange the new.
Water, plain H2O,
sustaining life,
precious life.
The snow stacks deep
up in the high hills
turning to rivers of ice.
Powerful, beautiful, ancient;
gouging out wide valleys,
tearing down their birthplace.
The hills, they rise again,
and again.
Water freezes in a crack
and crumbles the Earth
while the volcano erupts.
A dead tree falls in the forest
and rots,
nourishing the soil,
as a seed sprouts through the thick moss
and,
in the sunshine, begins;
begins its journey toward the sky.
And the rain falls again,
and again,
feeding the thirst
of precious life,
cleansing the Earth,
dampening the dry.
In the filtered sunlight
the moss grows thick
and the ferns grow tall.
And...
so it goes,
as we spin,
again and again.

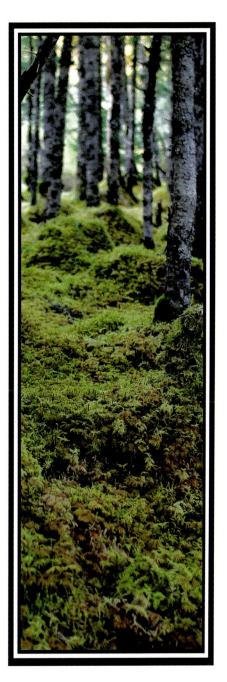

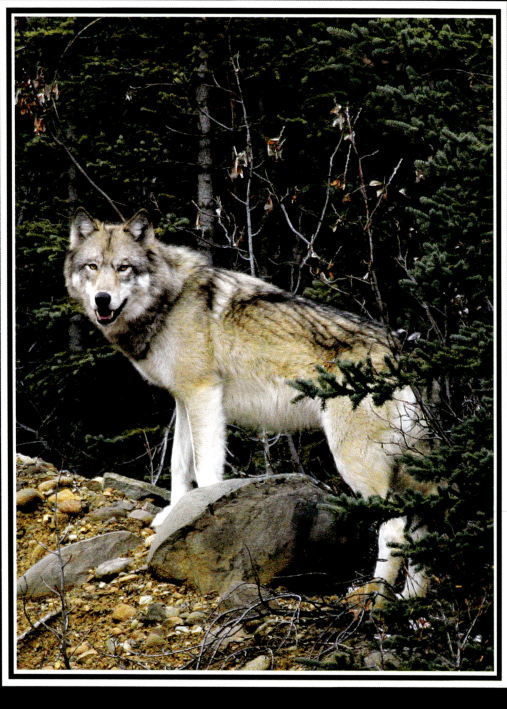

Wild Places

The wolf, it is feared and the wolf is revered;
 it depends on the person you ask.
They are a whole lot like us, they'll fight and they'll fuss.
 When hunting they're up for the task.

I think that they're feared and also revered
 because they possess a lot of our traits.
They live social lives with life long husbands and wives;
 they have something that deeply relates.

They live in communal packs and watch each other's backs
 as they live out their lives in the wild.
Wolves care for each other like a sister and brother
 who show love but are easily riled.

They tend to travel together in all sorts of weather
 as they search for food out on the land.
They will howl in the night under a full moon so bright
 to stay in touch with the rest of their band.

The pups like to play on a mid summer day,
 they will nip and chase each other's tail.
They'll rest in the sun after a morning of fun
 and they will pay attention to the dominant male.

The alpha mom knows when the alpha dad shows
 his teeth that it's time for a kill.
They will gather the pack and head out to track
 a meal with their refined hunting skill.

A lone wolf will howl like a hoot of an owl
 in an effort to find a life long mate.
If a howl comes back strong it won't be too long
 until the two of them will be off on a date.

Two wolves sit on a kill on top of a hill
 and let out a howl to gather the pack.
They will come for the feast from the west and the east
 and together they will enjoy a big snack.

I think all of the fears conjured up through the years
 are because they are human like creatures.
But there is also a love because they are part of
 a social order that puts faith in its teachers.

There are two sides to the story, either heartfelt or gory,
 and the wolves are caught in between.
But without the wild places where wolves show their faces
 our hearts will become empty and mean.

Wild Places

We must cherish the wild like we cherish a child
 in order to learn from the sacred professor.
It has so much to show that helps us to grow,
 without it we would only be lesser.

Our existence depends on our natural wild friends
 that make up the web of the living.
The natural cycle is pure and can sustainably endure
 precious life through all of its giving.

Life on this Earth to death and from birth
 is enhanced by its never ending changes.
Its meaning is measured by the things that are treasured
 and the beauty of the power that rearranges.

It's not just the wolves or the wild animals with hooves
 that depend on the wholeness of wild places.
We also do learn how to grow and to yearn
 through the wonder we find in its graces.

The lessons are there and if we are aware
 we will find the answers by seeing
that this is the grease that lubricates our peace
 and contributes to our over all well-being.

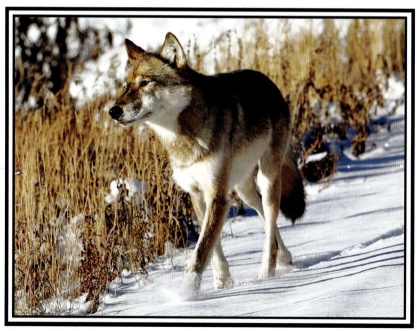

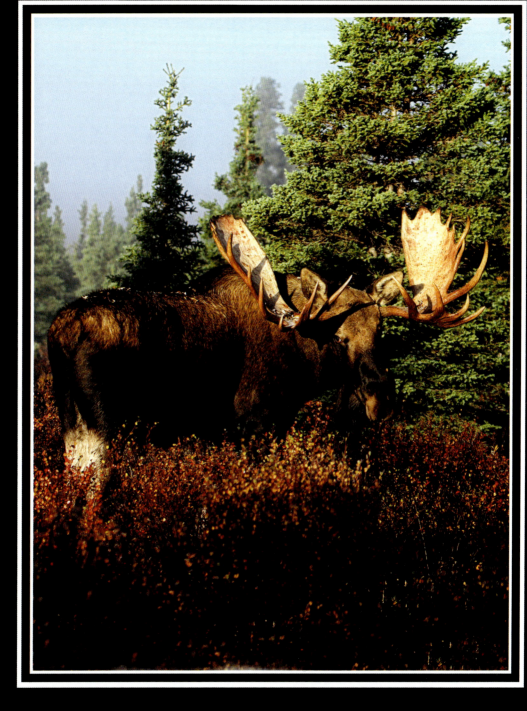

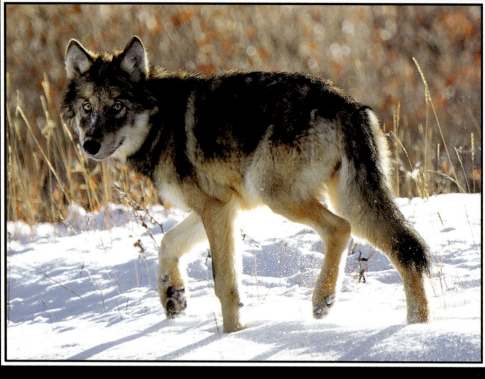

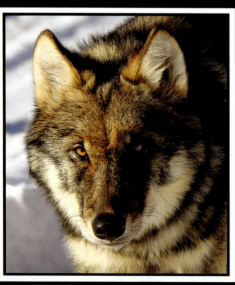

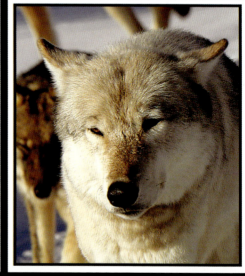

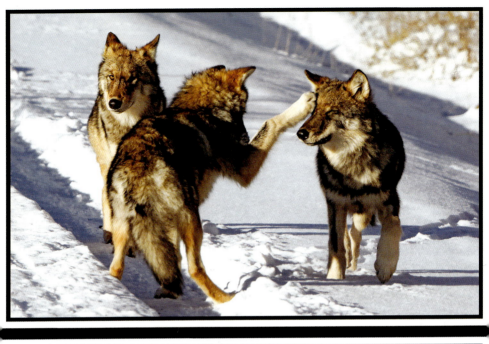
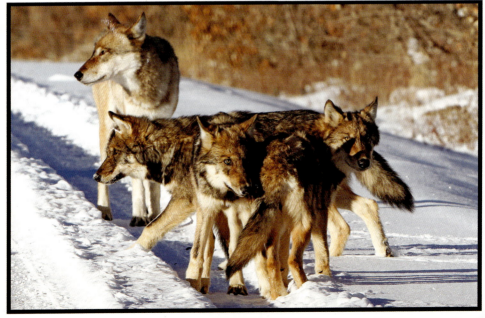

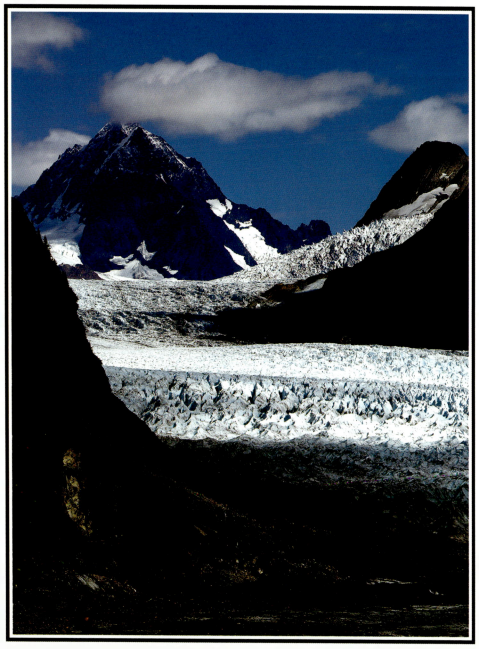

Rivers of Ice

Magnificent rivers of ice flowing powerful and sublime,
gradually sweeping downhill throughout the ages of time.

Gravity continually pushing the massive white and blue
from up high in the mountain peaks, way out of view.

Slowly, ever moving, scouring mountains along the way;
u-shaped valleys are formed from the perpetual decay.

Plucking rocks, rolling boulders that are crushed into gravel;
encouraging high places to crumble and unravel.

Snowfall adds weight and turns into ice under pressure.
The ice melts into water, the ultimate refresher.

The hues of the blues of these ancient ice streams
are so intense it's unreal, or, at least, so it seems.

Moulins and crevasses that are holes and big cracks;
bergschrunds, icefalls, snowbridges and seracs.

Terminal, lateral and medial moraines;
glacial outbursts overwhelming flood plains.

Rock pulverized to fine particles known as glacial flour;
forces so immensely strong it's hard to imagine such power.

Tarns and nunataks and large, lonely erratics;
the wholeness of their being depends on climatics.

Piedmont, tidewater and hanging from steep mountains;
there are polar and valley and loud calving ice fountains.

Advancing, retreating, stable and sure;
their beauty and power have a far reaching allure.

Standing nearby and watching them calve,
for the heart and the soul is a spiritual salve.

They store fresh, pure water and release it quite slow.
These fascinating fountains of ice are recharged by the snow.

They build up and melt down and meander through time.
The glaciers of the Earth, so powerfully sublime.

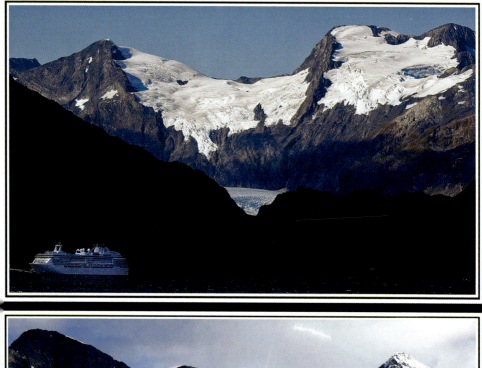

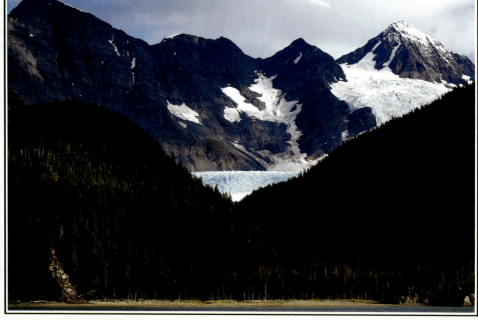

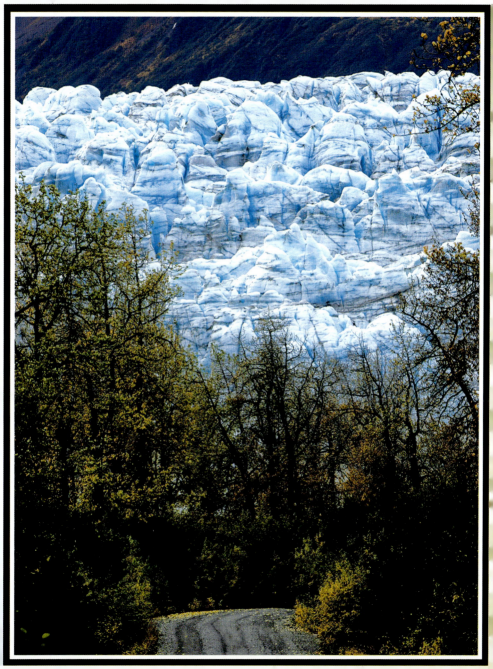

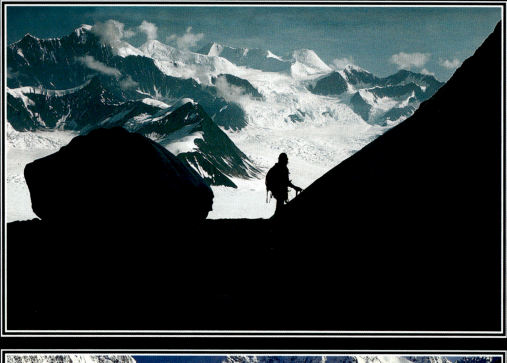

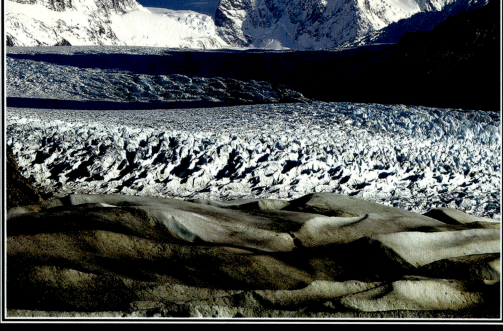

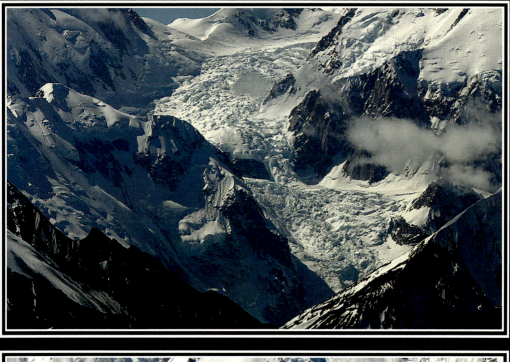

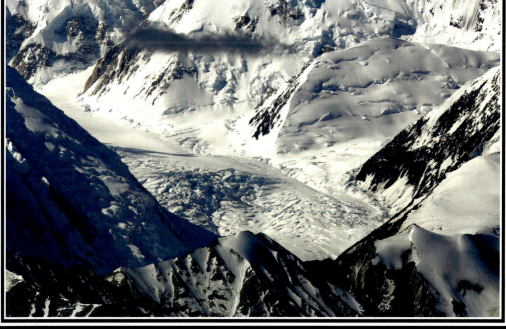

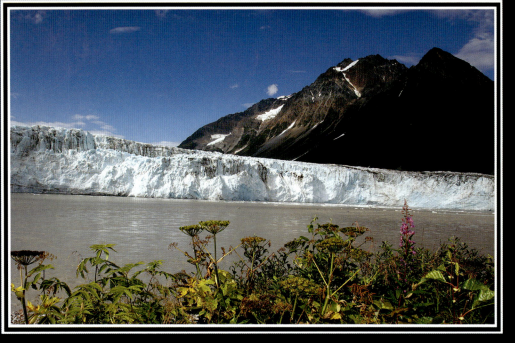

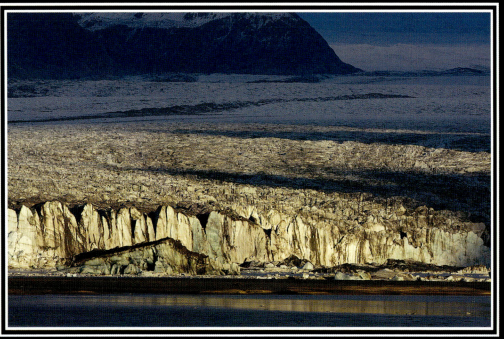

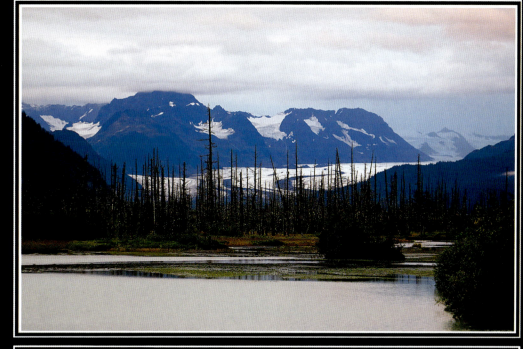

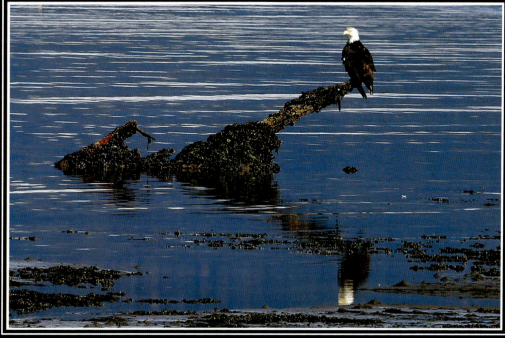

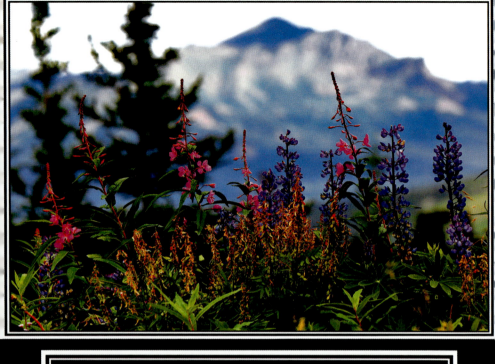

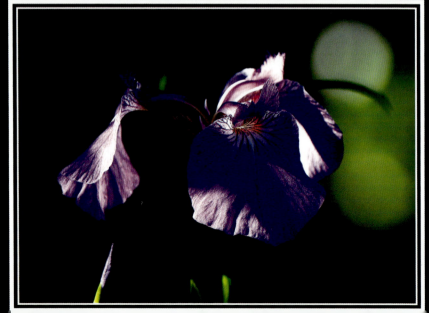

The Wholeness of it All

There is a wholeness in an untamed forest that goes beyond all thought.
It's deeper than all comprehension, it cannot be named and can't be taught.

There is a stillness in the wind that is pure and oh so true.
We can't see it and we can't hold it, it is there but it is out of view.

A mighty river's current flows strong, it meanders and never ceases.
We cannot begin to understand the connection of all of the pieces.

The pieces of all of the liquids, the solids and all of the gasses;
the pieces of the fragrant flowers, the tall trees and the bent over grasses.

The wholeness of the universe and the connection of all of its places
is glimpsed with our eyes, held in our hearts and reflected in our faces.

The deepness of this reality has always been around.
This deepness can only be explained without uttering a single sound.

It can't be explained with clever concepts or sophisticated knowledge.
It cannot even be explained in the most advanced courses in college.

It can only be expressed through a sincere deep pull in our heart.
It can be expressed through poetry, through song and also through art.

The wholeness that is there in the sun, the moon and the sky
consists of an energy so strong that it is actually quite quiet and shy.

Shy in the sense that we can't see it and we certainly cannot hear it,
yet we can feel its presence in our soul and we know it in our spirit.

We know it when walking through a forest that is wild, deep and dense.
It is a knowing that is so subtle yet profoundly clear and intense.

Life as we know it is sustained by the totality of the connected whole.
The connectedness of it all feeds the open heart and the sacred soul.

There is a feeling at hand when we experience this genuinely sincere deep pull
that fills our senses with wonder and keeps our perspective light and full.

Full from the wholeness that connects the amazing vast grand flow,
that nourishes and strengthens this incredible life that we know.

It is a beauty that is so deep that it can be overlooked and missed.
It's so deep yet it is so simple and it helps us to thrive and persist.

Everything recycles and returns to the wholeness of being.
To open up and feel this is soothing and truly freeing.

It opens our minds, soothes our souls and it frees up our tattered heart.
And it puts all things in perspective by deeply feeling our simple part.

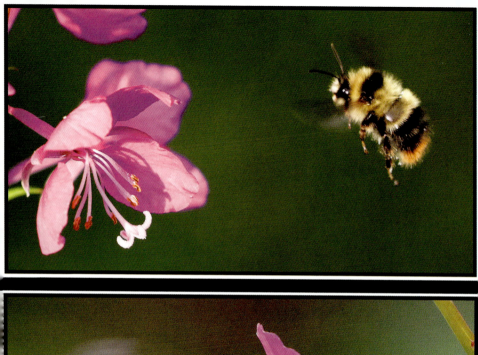

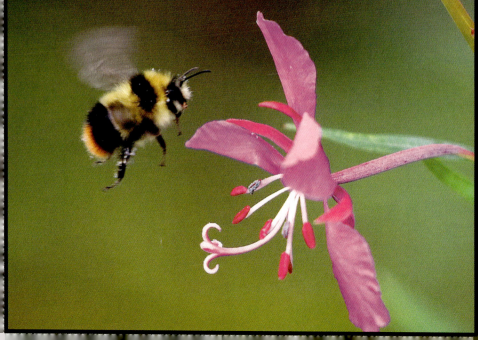

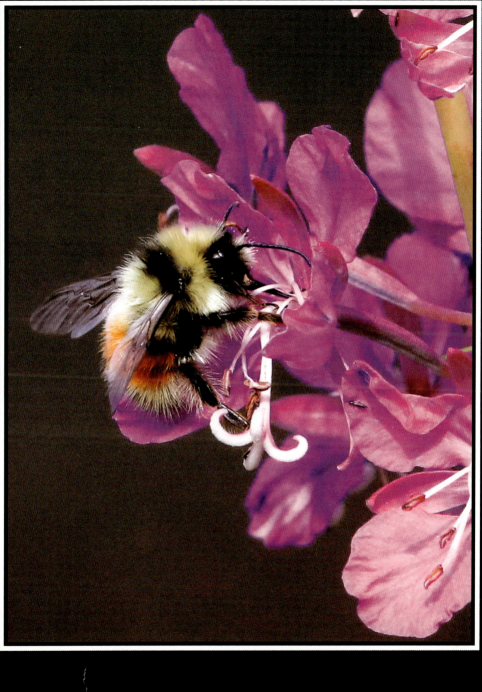

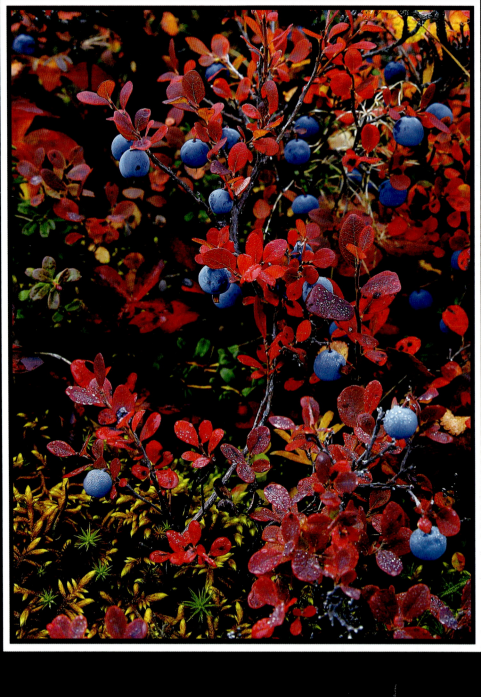

The Showing and Slowing Season

Autumn in Alaska is a short and beautifully bittersweet season.
Going from warm long summer days to shorter days and dark nights that start freezin'.

It is the prelude to the long months ahead of winter time's deep cold.
It is a time of abundant harvest as its brilliant colors unfold.

Gardens are laden heavy and the silver salmon are in their prime
and if you like pickin' wild berries this is certainly the perfect time.

There are high bush cranberries, crowberries and blueberries everywhere.
There are rose hips, currants and gooseberries; there is crispness in the air.

Raspberries, watermelon berries and salmonberries, juicy, plump and large.
Bull moose battle for dominance ready to fight with a snort and a charge.

The aspen, the cottonwood, the birch and the thirty-three species of willow
are emblazoned with yellow leaves as the wood stove smoke starts to billow.

There are crimson red dwarf dogwood and bright red dwarf birch.
All of the migrating small birds barely stop to briefly perch.

They are heading south in a hurry to escape the winter's grip
along with many larger birds on this lengthy yearly trip.

There are ducks, grebes and geese and the prehistoric looking sandhill crane.
Golden eagles, gulls and hawks, not many birds make the choice to remain.

Autumn feels rather mellow but can be a busy time of the year
as preparations for the winter season move right on into high gear.

Stars begin to reappear and once again show themselves at night,
as well as the spectacular enhancement of the aurora's sweet glowing light.

Toward their wintering ground the caribou begin their yearly roam.
The humpback whales head south for a warmer winter home.

The abundance of the northern summer has ended its primal call
with a natural flowing transition into this season known as fall.

Autumn sneaks in quietly and the rivers begin to slow.
This season is intermixed with the presence of pure white snow.

As autumn in Alaska ends and gives way to the winter scene
it is perfectly peaceful and quiet and refreshingly serene.

Fall in the north is calming and is an entrancing time of the year.
Autumn is a truly treasured season in this fantastic last frontier.

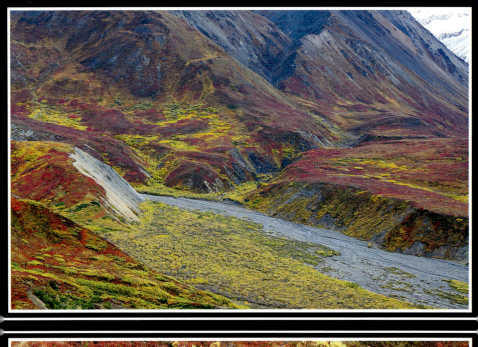
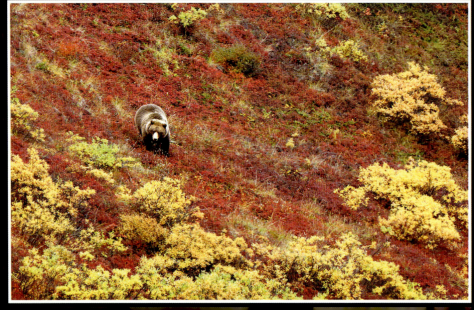

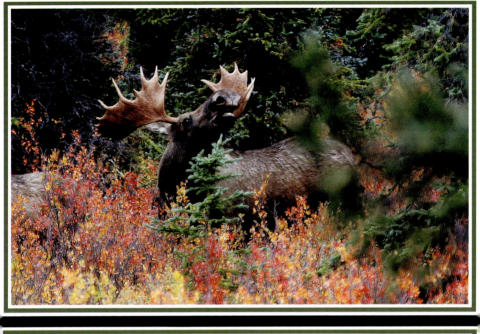

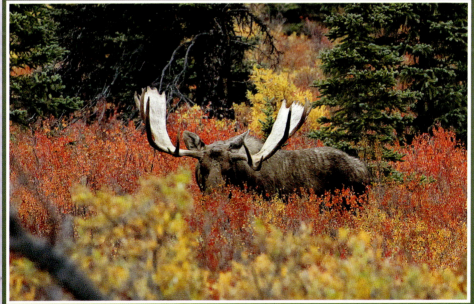

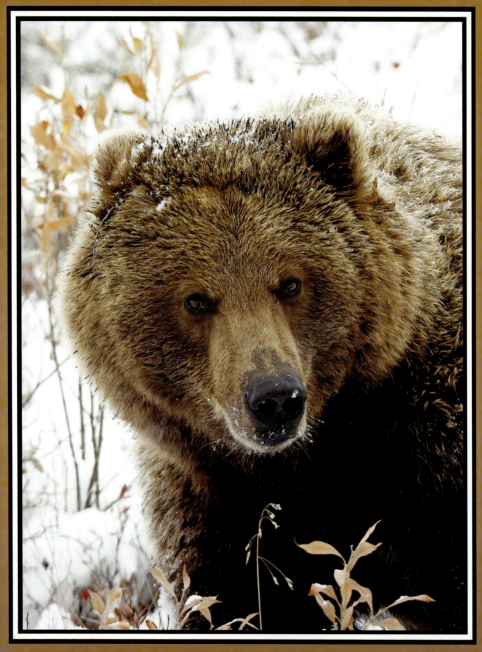

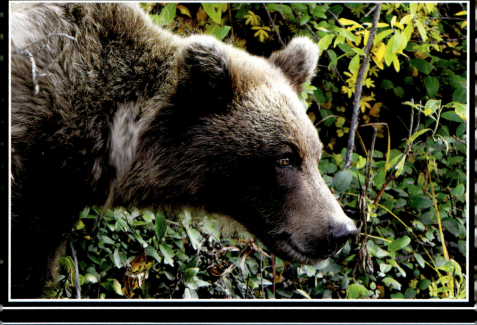

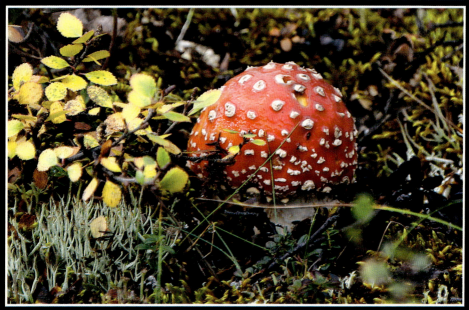

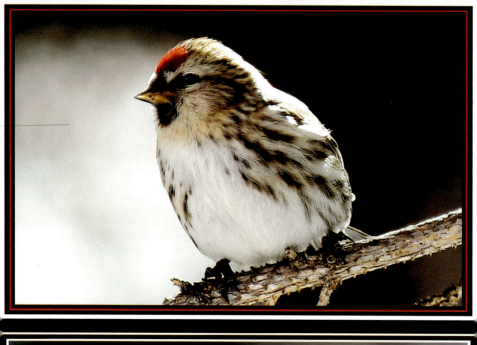
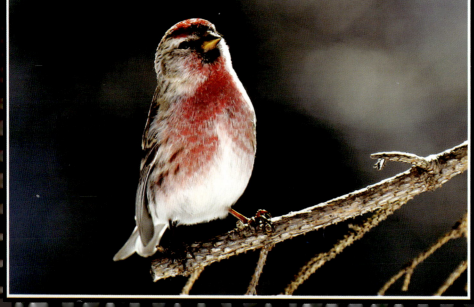

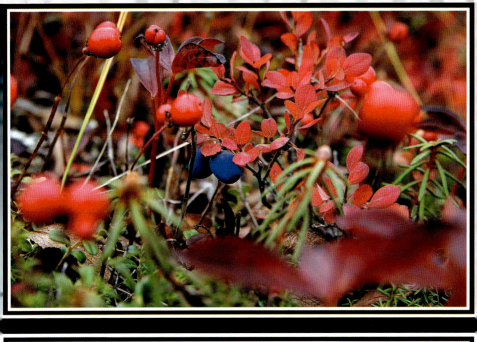

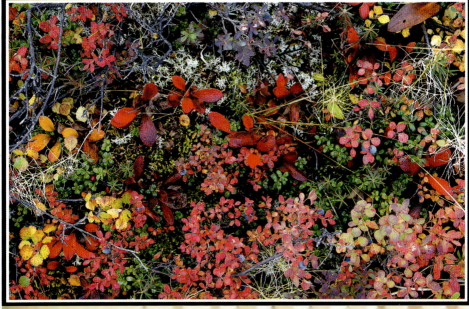

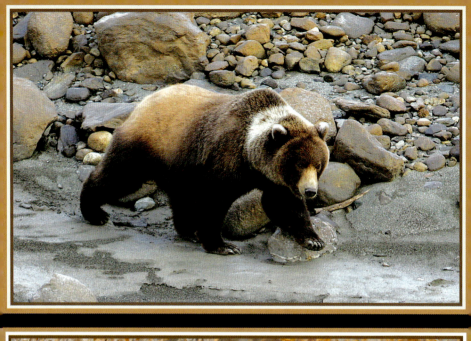

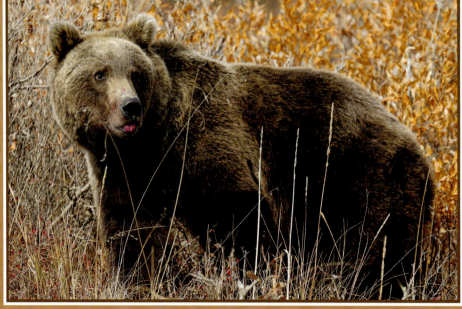

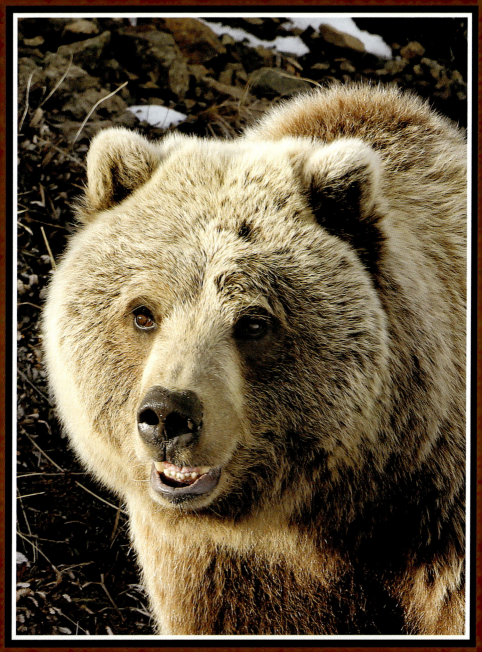

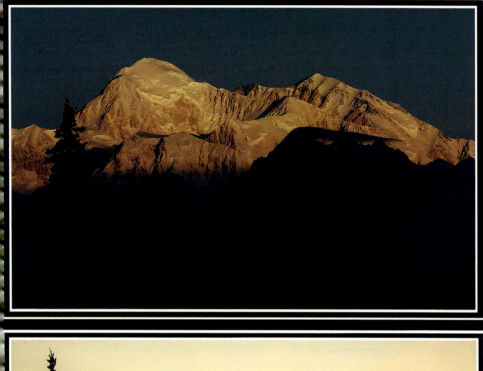

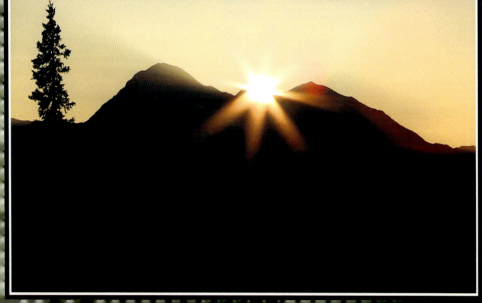

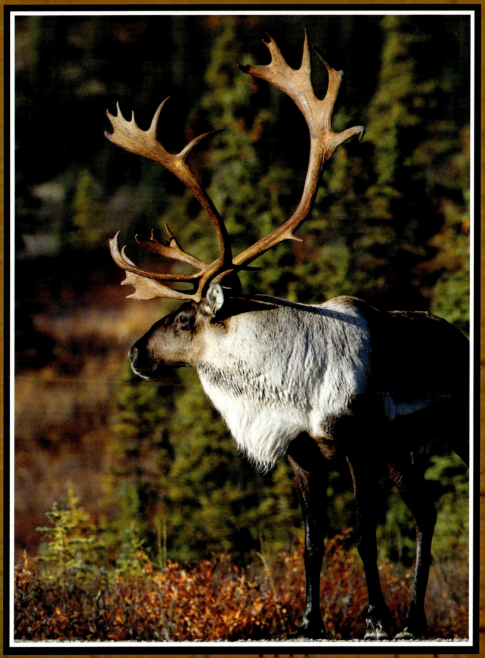

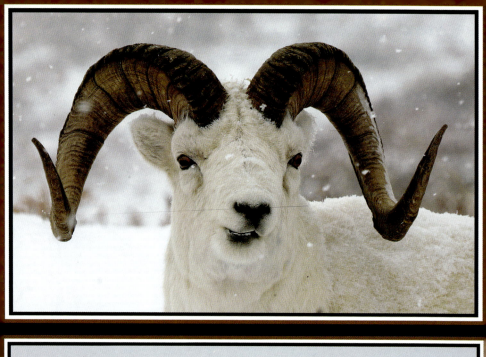

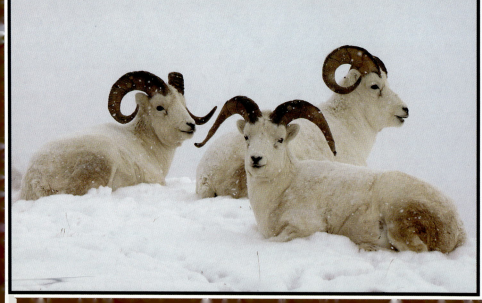

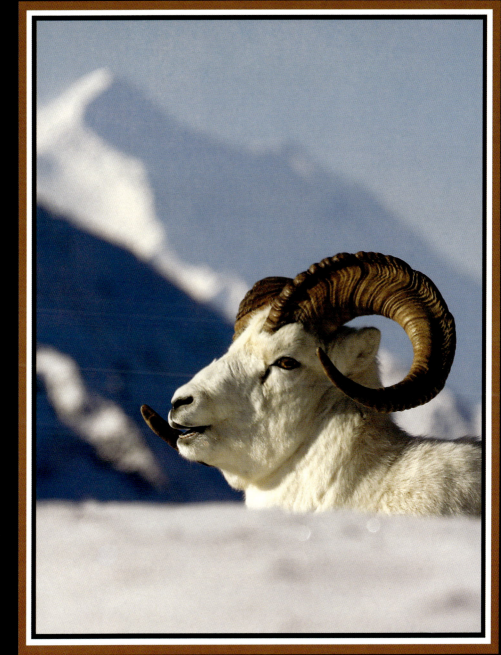

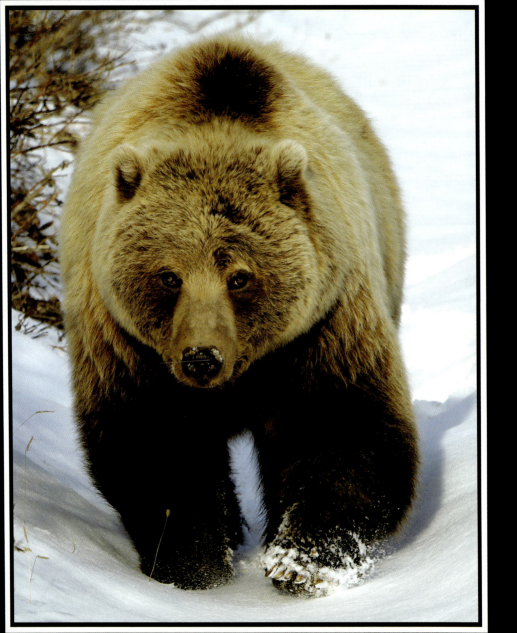

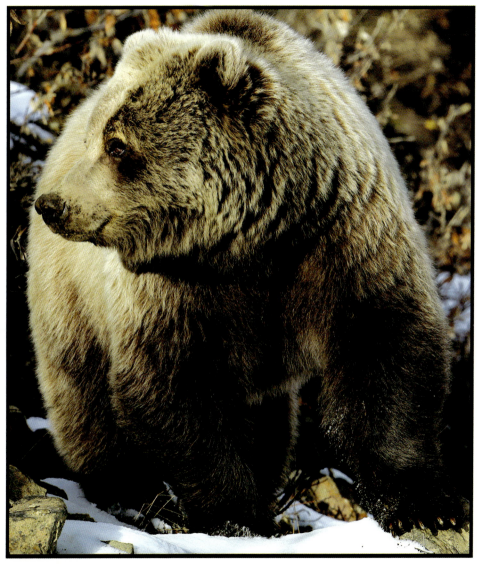

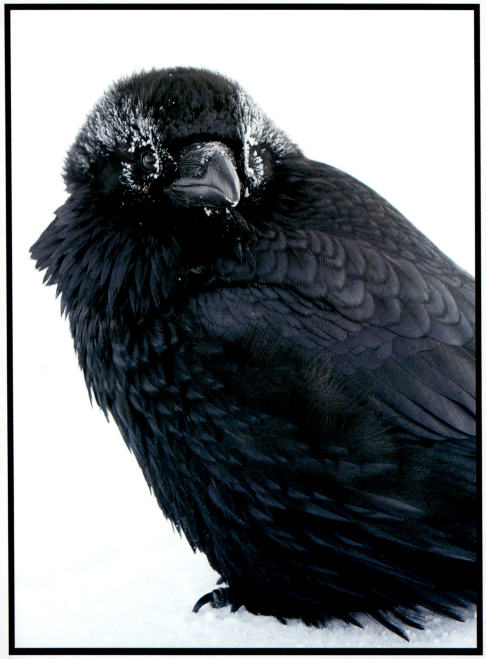

Big Black Birds with Big Black Beaks

On the north side of the Alaska Range it is a quiet 48 degrees below.
The calm silence is interrupted by the flapping wings of a giant crow.

As it flies overhead it lets out a very unique and interesting sound;
kind of a glook and a gurgle that is captivating, intriguing and quite profound.

Not far behind its life mate follows with a very similar response
as they cruise above the treetops with their trademark nonchalance.

Together they dive and climb and do a barrel roll or two.
They scan the land for a meal as they fly on out of view.

A wolf pack takes down a caribou on a frozen river's edge.
The big black birds with big black beaks watch from a nearby ledge.

These ravens can endure such cold because they are intelligent and aware.
They are opportunistic creatures and take advantage of whatever is there.

They will eat small rodents and carrion and whatever predators leave behind.
They'll eat seeds and berries and garbage, they'll eat just about anything that they can find.

In the summer they watch the bears closely and are said to have led them to prey.
They are a member of the Corvidae family which includes the crow, the magpie and jay.

The raven is one of the smartest animals on this beautiful spinning sphere.
They have about 30 different vocalizations, some are quite soothing to hear.

Largest of all the songbirds, the raven is an extremely exquisite flier.
I've watched them catching thermal winds, doing acrobatics as they circle higher.

With winds so strong you would think they are grounded and there they are flying with glee;
Soaring with the wind as if it's their friend, flying playfully and ever so free.

These big black birds with big black beaks hold spiritual significance to humankind.
They are so much like humans in so many ways, our spirits are intertwined.

Ravens can hold a special place in your soul and make your heart open and glisten.
So the next time you see a pair of ravens in flight, stop, take a look, and listen.

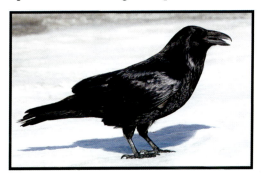

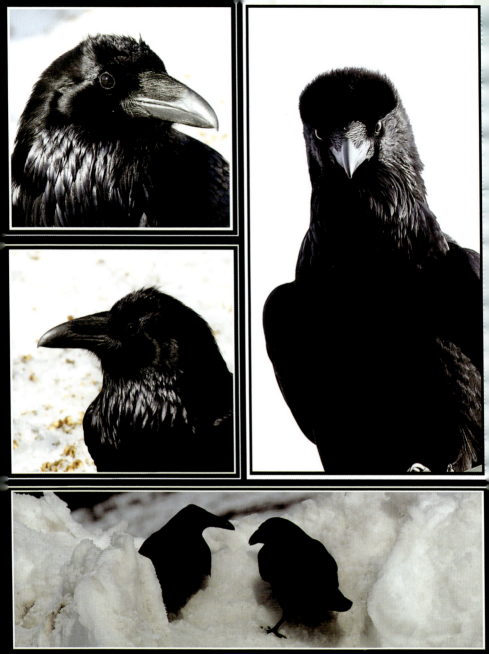

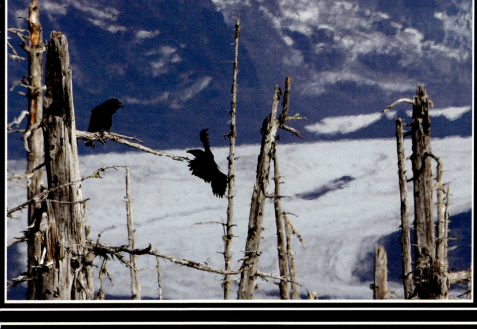

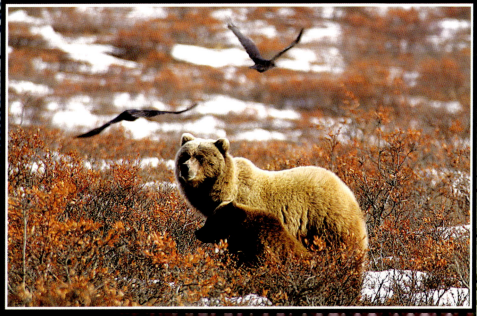

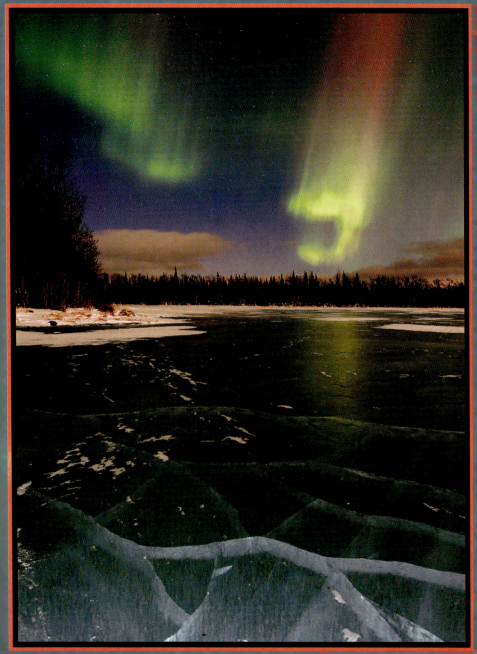

An Awakening of Light

I was laying on my back on the glare ice of a cold, hard frozen clear lake
listening to the hoots of a Great Horned Owl as the aurora began to awake.

There was a band of green light glowing and getting brighter and brighter quite fast.
It turned into curtains of brilliant light dancing across the night sky so vast.

There were pinks and purples and yellows, so many different shades of red.
It made me feel like dancing along so I got up off of my cold icy bed.

The light show was filling the sky to the north, the south, the east and the west.
I started shooting photos in all directions, I was astonished and certainly impressed.

On occasion the aurora was so bright that it seemed like the middle of the day.
There were swirling curtains and ovals of colors; there was no wind but it blew me away.

I was out on the ice for six hours and the intensity would come and would go.
With flares of light pulsating off and on, it was definitely a dazzling light show.

The streaks of light were reflected off of the smooth ice that was under my feet.
With a flash of my headlamp I captured images of the cracks in the ice that were neat.

I was amazed at the photos I was getting of the ice cracks, the reflections and the lights.
Standing in the middle of a frozen lake in silence, this was one of the most memorable
of all of my nights.

Experiencing the Northern Lights streaming through the sky like this and seeing them
brightly aflame
awakened a special place so deep in my soul and I will never be quite the same.

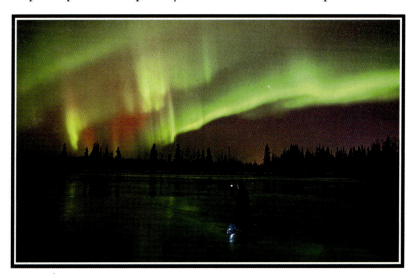

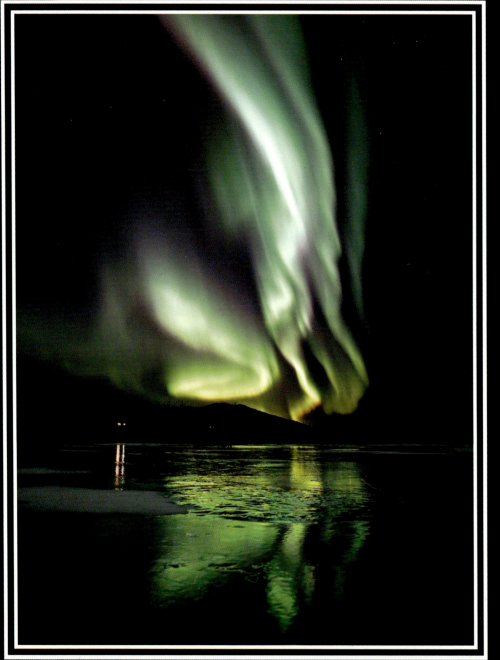

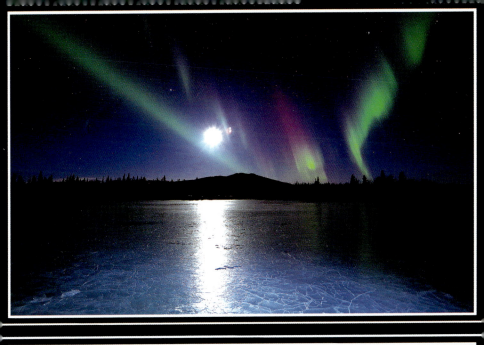
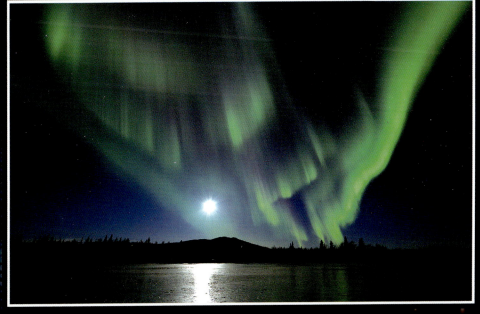

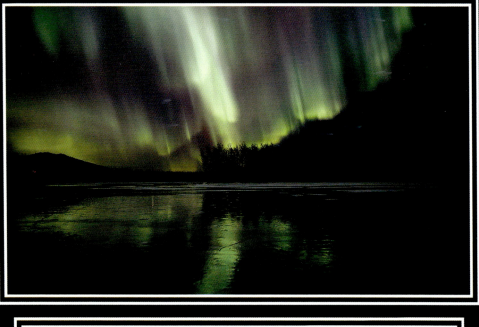

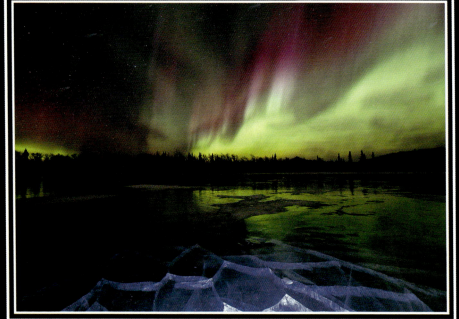

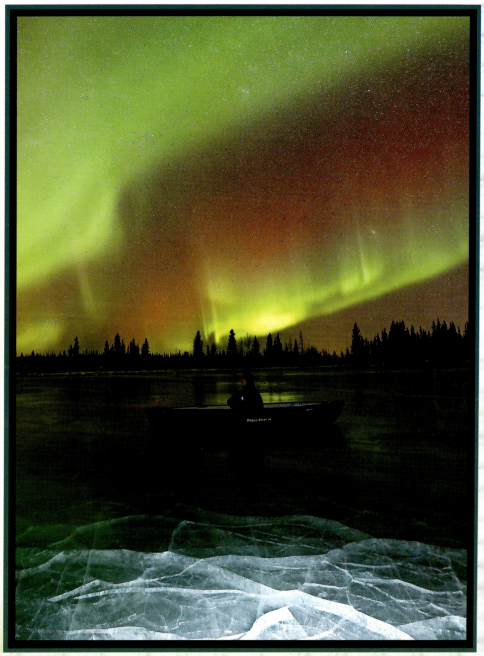

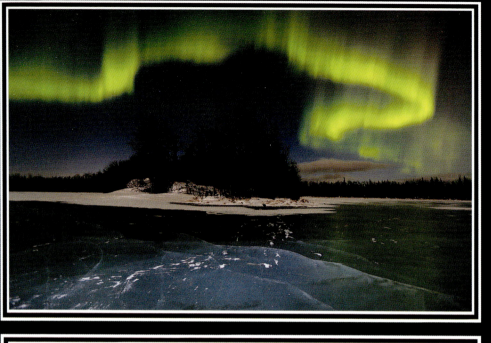

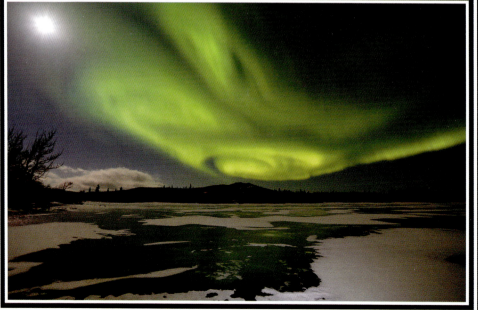

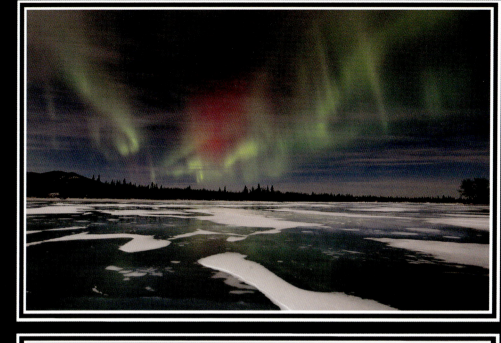
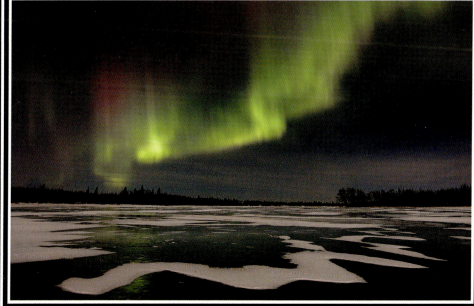

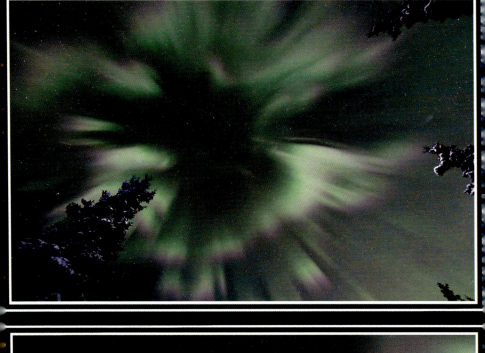
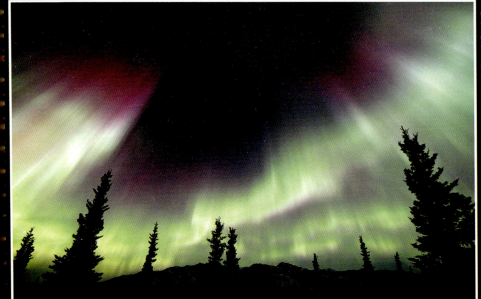

Precious Moments

As the thick clouds parted and the night sky cleared
the view of endless stars suddenly reappeared.

In the shape of a backwards S was a shimmering light
that soon transformed the cold, dark and quiet night.

It had started out as a dull white, yellowish green
and quickly turned into a spectacular scene.

Green streaks were capped with purple and pink
as the yellow crescent moon continued to sink.

It sunk past the horizon and down out of view
as the light show unfolded, got brighter and grew.

The sound of wolves howling off in the distant hills
sent a shiver down my spine and filled my body with chills.

They were chills of delight knowing that this was unique.
Silence interrupted the primal sounds, I felt the mystique.

The sounds from the hills to the sights in the sky,
with the deep silence intermixed, I felt a natural high.

It was a high I had felt before from totally immersing in the now.
It was intense, yet pure and simple, it felt healthy, I yelled wow!

And the lights up above, they curtained and streaked
as the ice on a nearby pond softly crackled and creaked.

The wolves yips and their howls echoed off in the distance
and the wondrous light show fizzled out in an instance.

Precious moments like these, they come and they go;
feeling them deep in our hearts is a great way to grow.

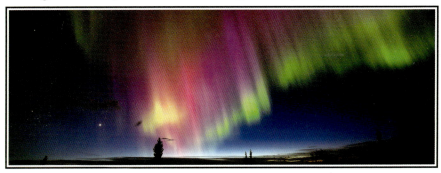

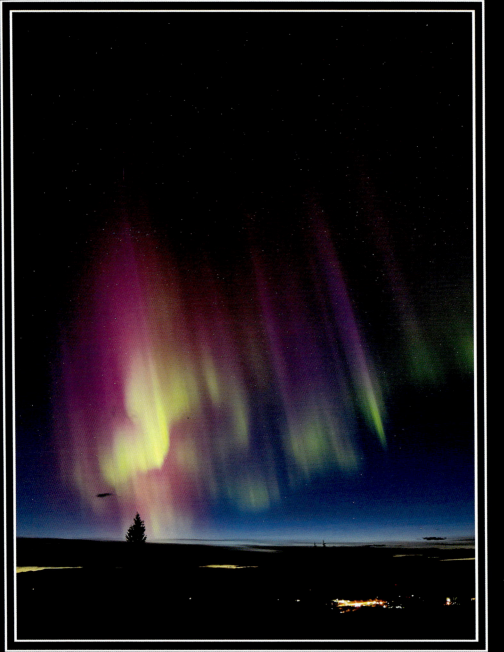

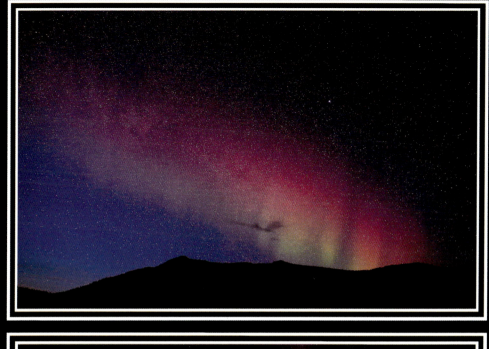
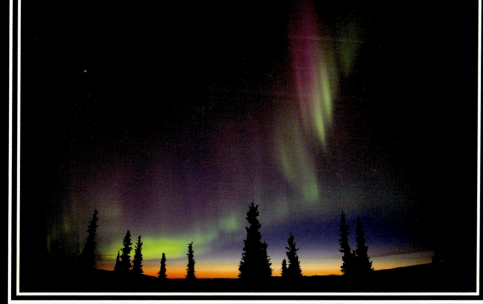

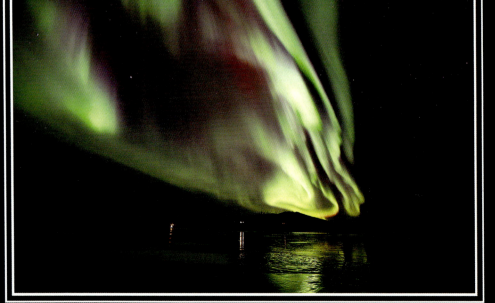

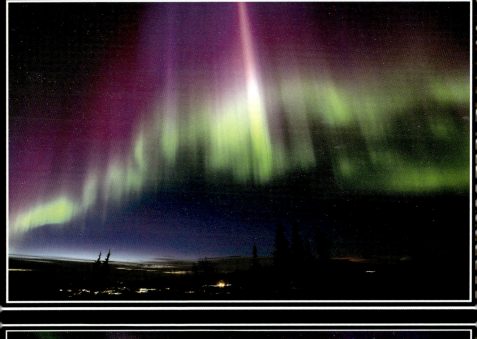
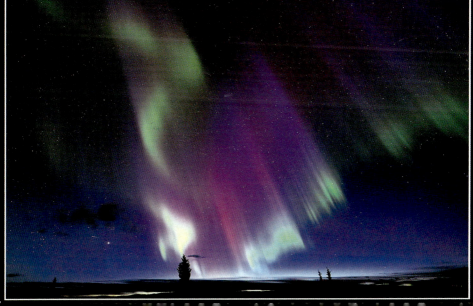

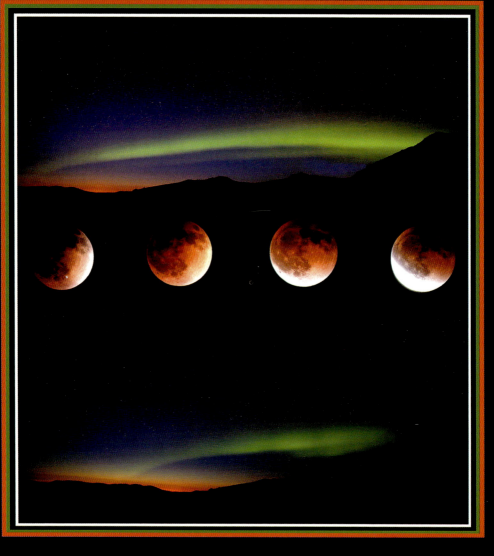

This is a montage of six images shot right after each other on the same night. The images of the lunar eclipse were taken between 11:17 pm and 12:28 am on April 14 & 15, 2014 looking to the south and during the same time period the Northern Lights images were taken looking to the north with the late setting sunlight on the northern horizon.

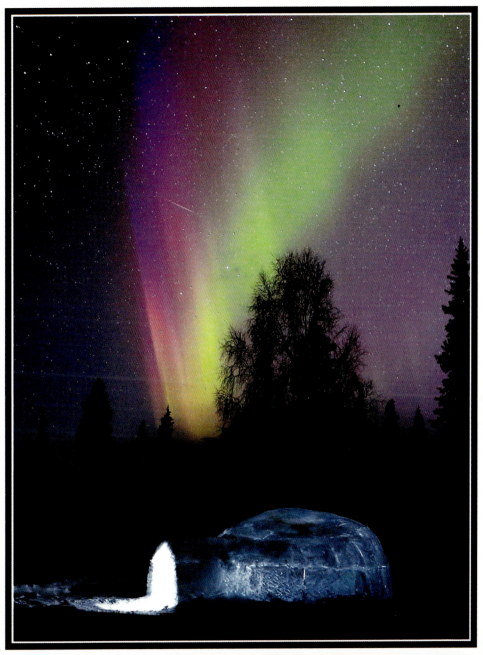

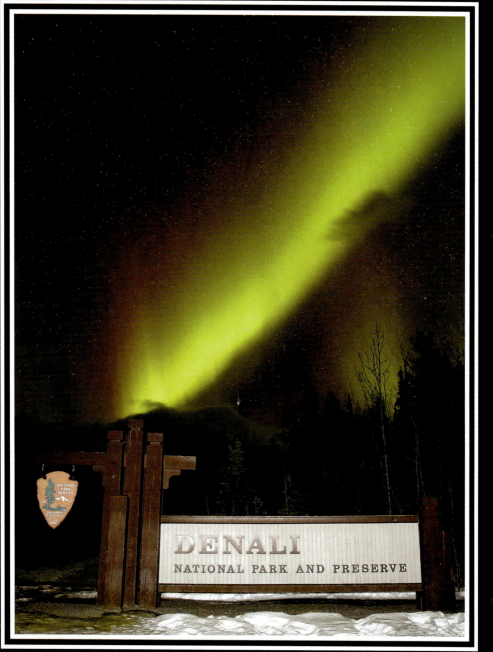

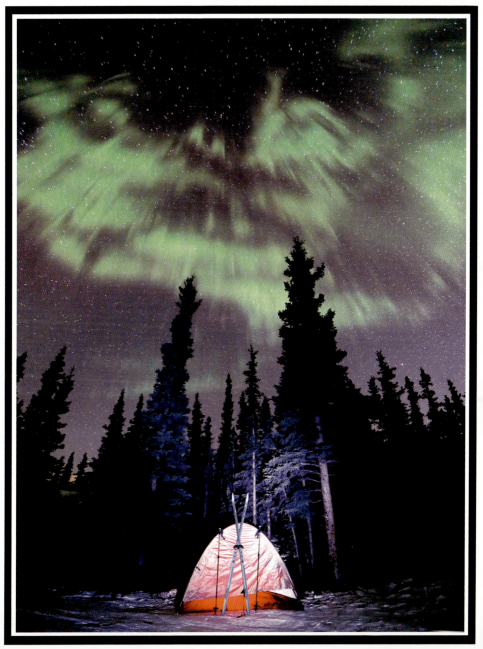

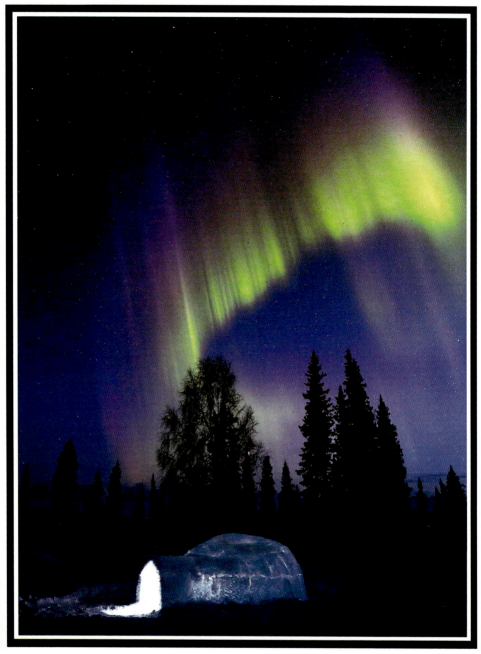

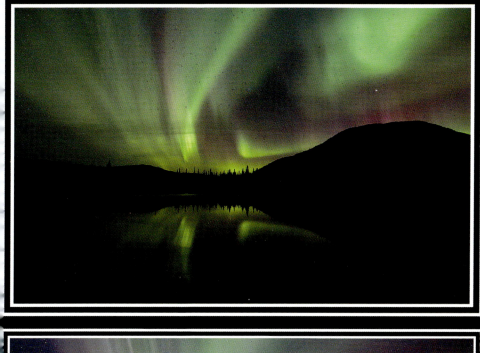
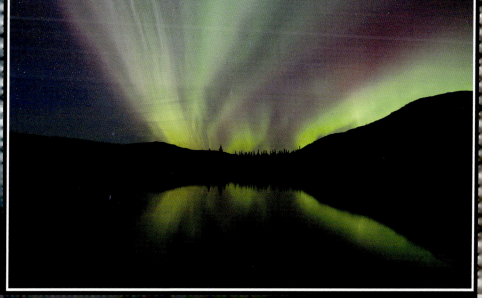

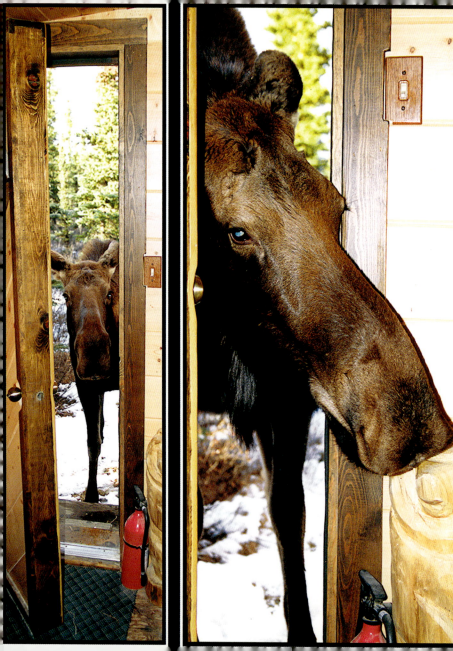

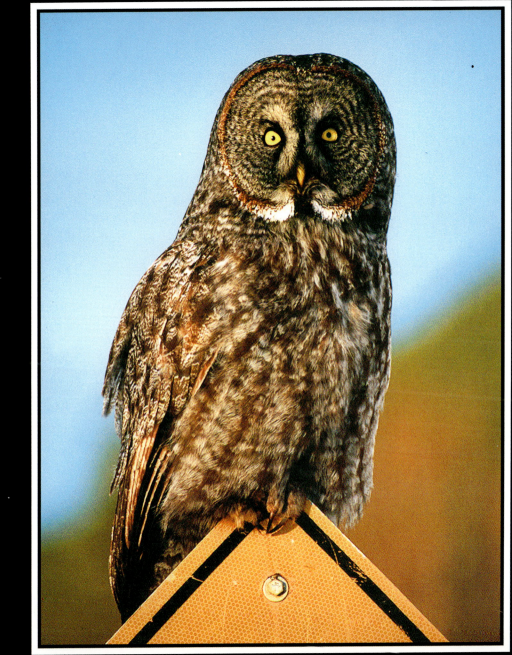

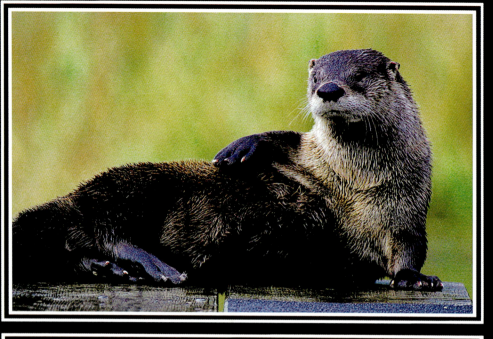
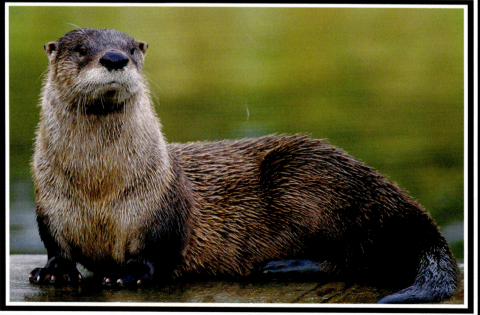

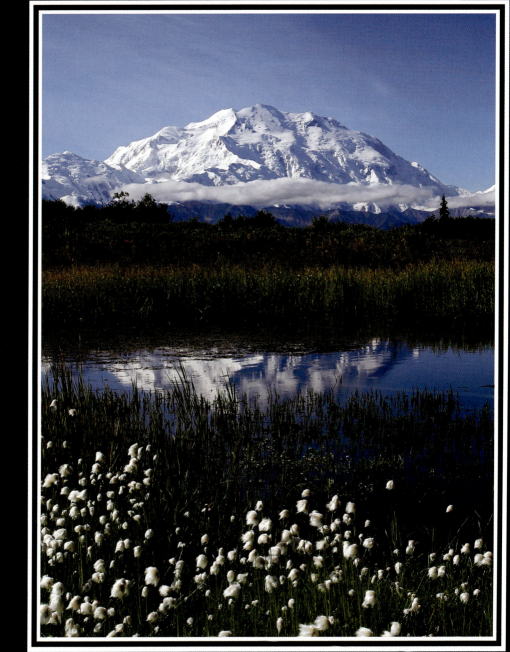

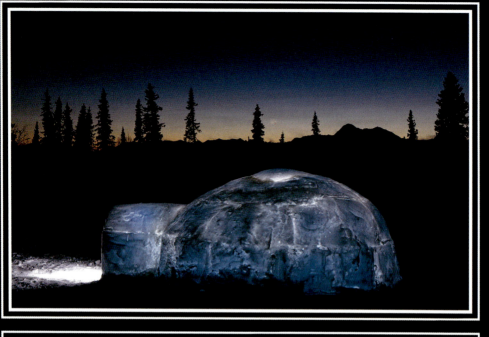
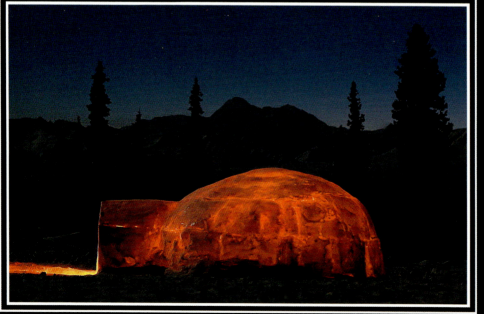

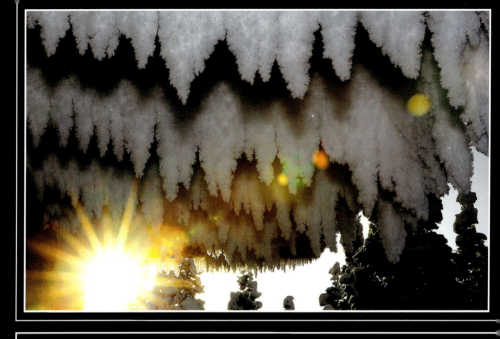

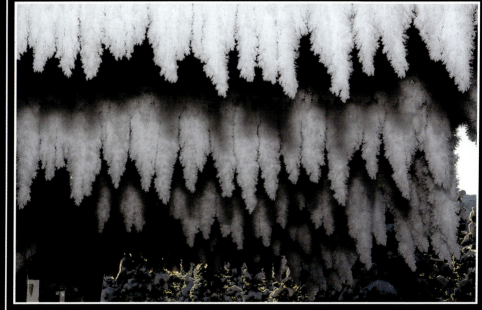

About the Photographer / Poet

Jimmy Tohill was born in 1959 in Dallas, Texas. He started taking pictures of wildlife and the great outdoors when he was 10 and began writing poetry about his passions when he was 13. Tohill attended Fort Lewis College in Durango, Colorado where he studied natural history, biology, skiing and mountain climbing. After falling in love with nature and adventure photography Jimmy started his first professional photography business in Durango in 1981 where he shot white water rafting photos on the Animas River, ski area photos at Purgatory ski area, weddings, portraits and wildlife and landscape images. In 1987 Tohill made a move north to Alaska to be a river guide and photographer at Denali National Park. He ended up guiding many places around Alaska and finally bought land in Healy, just 10 miles north of Denali Park, in 1994 and, with his lovely wife, Vicki, began to build their scribe fit log home. They lived in a 12 x 16 cabin with no running water for 6 years while they hand built their home, out of pocket. They now live with the comforts of running water in their cozy log cabin in Healy. Jimmy and Vicki have owned and operated Old Sourdough Studio at the McKinley Chalet Resort in Denali since 1998. Old Sourdough Studio is a very unique photography studio with a state of the art digital lab that also specializes in taking white water rafting photos on the Nenana River.

A sincere passion for life in Alaska continues to entice Tohill to get outside and experience the wonderful Spirit of Alaska and capture it with his camera, his pen and his heart in an effort to, not only enhance his own life, but, attempt to share the magnificent splendors of the great outdoors with folks from all over the world. Jimmy still enjoys climbing mountains, back country skiing, running wild rivers, surfing, simple walks in the woods, and spending time with his family, friends and especially his wife, Vicki.

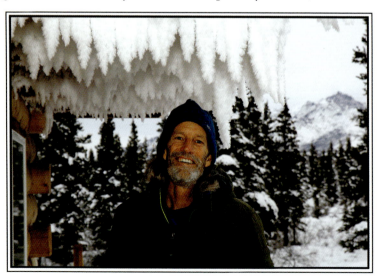

Index

Index

Index

Index